Pageant and Panorama

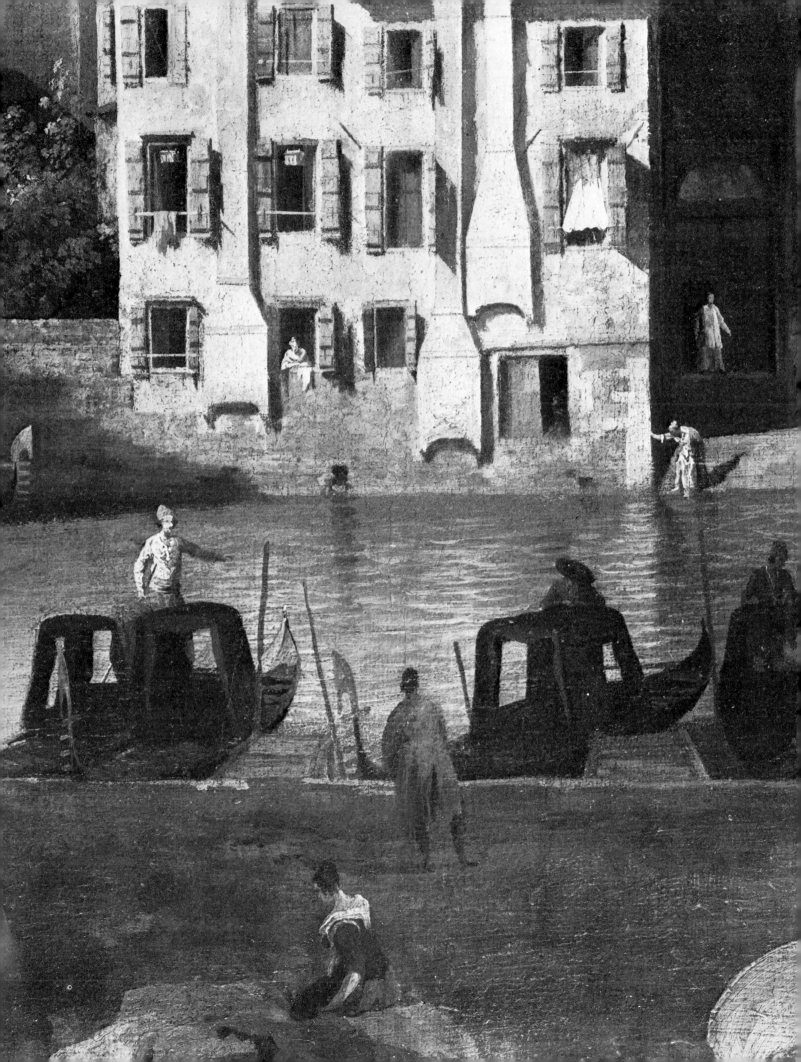

Pageant and Panorama

THE ELEGANT WORLD OF CANALETTO

Homan Potterton

Phaidon · Oxford

Phaidon Press Limited, Littlegate House,
St Ebbe's Street, Oxford

First published 1978
Published in the United States of America by E. P.
Dutton, New York
© 1978 by Phaidon Press Limited
Text © 1978 by Homan Potterton
All rights reserved

ISBN 0 7148 1856 9
Library of Congress Catalog Card Number: 78-56668

Printed in Great Britain by Waterlow (Dunstable) Ltd

The definitive text on Canaletto, unlikely ever to be
superseded, is W. G. Constable, *Canaletto, Giovanni
Antonio Canal 1697-1768*. Second edition, revised by
J. G. Links (2 Vols, Oxford 1976). It would be impossible
to write about the painter or his world without incurring
a heavy debt to these volumes. In this respect the present
book is no exception.
The most authoritative and up-to-date account of the
etchings is Ruth Bromburg's *Canaletto's etchings*,
London, 1974.
*Il Quaderno di disegni del Canaletto alle Gallerie di
Venezia* is a facsimile of a sketchbook published by
Terisio Pignatti with catalogue and commentary,
Milan, 1958.
For a recent general survey see *Canaletto and his
Patrons*, London, 1977, by J. G. Links. H.P.

Plates 11, 14, 34, 35, 37, 49, 50, 51, 70, 77 are reproduced
by gracious permission of Her Majesty Queen
Elizabeth II.

1 (frontispiece). *The Stonemason's Yard*. Detail of Plate 6.

List of Plates

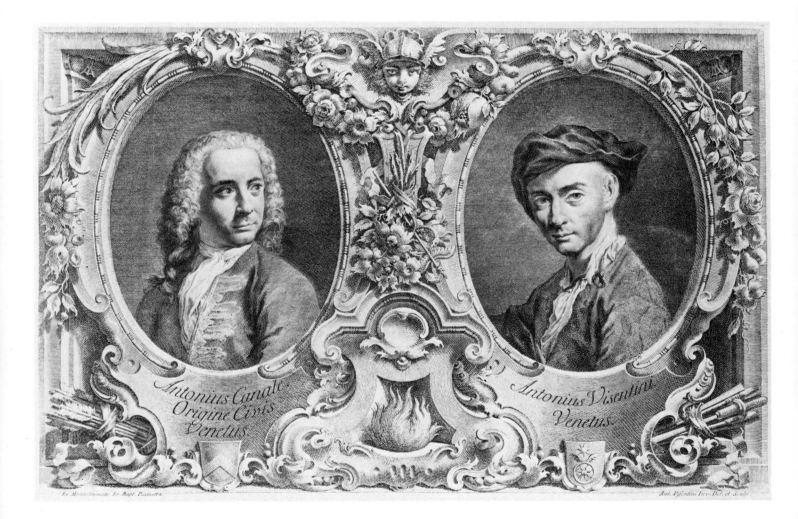

2. Engraved portraits of Canaletto and the engraver Antonio Visentini from the book of engravings after paintings by Canaletto in the collection of Consul Joseph Smith. The book, which was called *Prospectus* *Magni Canalis Venetiarum...*, was published in three editions in Canaletto's lifetime, in 1735, 1742 and 1751. Oxford, Ashmolean Museum.

6

Many artists, poets, writers and painters have been attracted by the pageants and panoramas of the city of Venice. Most have been inspired by an awareness that such a magnificently decaying vision could not last and have tried to capture the essence of the city before its eventual and long promised demise. But Venice has been declining for centuries and, one suspects, will go on doing so for many centuries more. It is this sense of brave defiance which accounts for much of the poignant beauty of the city and much of the poetry in the art she has inspired.

Canaletto's response seems more honestly matter-of-fact than that of many other artists. That is not to deny he had genius—for that he indisputably had—but he seems not to have been beguiled by the city into painting other than what he saw. In his time the physical appearance of Venice cannot have been all that different from what it is today, although the period of the city's greatest prosperity was some two centuries nearer and Venice was still the 'Most Serene Republic'. Then, as now, she was much visited, and then as now most visitors liked her and a few loathed her. Liking or loathing Venice, few have denied the magic of the place—a shimmering wonderland rising in a lagoon.

Although, as in *The Stonemason's Yard* (Plate 6), it is only very rarely that Canaletto painted anything other than the 'pageant and panorama', we can see in his paintings, perhaps more than in the work of any other artist, the real Venice. And the fascination of so much of his work lies in the fact that it shows us Venice as we can still see her. Particular favourite spots are easily recognizable; bell-towers and chimney-stacks protrude above roof-tops in exactly the same places as they do today. Church doors and palace windows have awnings in exactly the same shape and colour as they still do, and, most fascinating of all, in their daily life Canaletto's people seem hardly to have changed in the two centuries that have since passed. The one great difference between Canaletto's Venice and the city of today is that nowhere in his pictures can one find a single ancestor of the hordes of pigeons that are now so much part of the Venetian scene.

This fascination with how like Canaletto's paintings are to reality inevitably leads one to wonder how he painted them, for whom, and why so many. And of the painter himself, who was he? How did he train? And where did he live and die?

Canaletto was born in Venice on 28 October 1697. His family, though not patrician, had a certain social status in the city and republic, where social status mattered much. This is best described by the words 'origine Civis Venetus' used by Visentini under the engraved portrait of the artist published in 1735 (Plate 2). The family were armigerous and used the arms of the da Canal family,

a shield with a chevron, which was also depicted by Visentini. In some of his pictures the painter used this device as a form of signature, often incorporating it as part of an architectural detail.

Most of the details of the painter's life are known to us from the writings of three contemporaries: the Frenchman Pierre-Jean Mariette and the Italians Antonio Maria Zanetti and Pellegrini Antonio Orlandi; although in their accounts of his activities and movements these three writers sometimes vary. Many of the details of the artist's stay in England are recorded in the notebooks of the gossip George Vertue, contemporary newspapers and the correspondence of his patrons.

The painter's father was a theatre-scene painter called Bernardo Canal. Canaletto himself was baptized Giovanni Antonio, although from an early age he referred to himself, and was referred to, as 'Canaletto'. He first worked, like his father, in the theatre, and it was probably with his father that, in 1719-20, he went to Rome and painted scenes for operas by Scarlatti, which were performed there at the Teatro Capranico in 1720. It was in Rome, according to both Orlandi and Zanetti, that he painted his first views. Although none of these are now known, the pictures of Roman subjects which survive from the 1740s are most probably derived from drawings made at this time as well as from the engraved work of other artists. Certainly by 1722 the painter had returned to Venice, where he was employed in the painting of a series of allegorical tombs. Within the next five years his practice as a view-painter seems to have developed very rapidly; by 1727 Owen McSwiney could write that the painter 'had more work than he can doe'. McSwiney advised a patron to affect disinterest in the painter's work in order to obtain the more rapidly (and the more cheaply!) some of the artist's Venetian views.

Most, if not all, of Canaletto's work was for a tourist's market. It was natural that foreign visitors rather than Venetians, who themselves inhabited the palaces which the painter depicted, who strolled in the piazzas which also formed his subject-matter, or who attended the regattas on the Grand Canal which he painted on several occasions, should patronize the artist. The Venetians scarcely required paintings of scenes that to them were a commonplace. On the other hand the painter became a fashion with visitors to Venice, and it was enough for one English Grand Tourist to return from Italy with a Canaletto for his neighbour and his neighbour's neighbour to want to do likewise. It was with the English that the painter was always most popular and he owed many of his contacts with English patrons to the offices of two men: Owen McSwiney and Joseph Smith.

McSwiney was an Irishman, an actor and an impressario, whose activities ranged from theatre management to art-dealing; during the first decades of the eighteenth century he was actively engaged in securing works of art on the Continent for Lord March (later 2nd Duke of Richmond). It was at the instance of Lord March that McSwiney commissioned from leading Italian painters of the period a series of pictures of allegorical tombs commemorating the lives of great and recently deceased Englishmen. Most of these tomb pictures were the product of collaborations between more than one artist, and Canaletto worked on at least two occasions with the landscape painter Cimaroli and also with Pittoni and Piazzetta (Plate 15). The *Tomb of Lord Somers* was completed by 1722 and bought by the Duke of Richmond. It was, therefore, among the very first paintings by Canaletto to reach England. A small group of letters from McSwiney to the Duke of Richmond survives and from these some

information about Canaletto's practices can be gained: details of his prices and of his collaborators at this early stage in his career, and also of his methods of working out of doors are contained in them; as well as the less flattering information that the painter was not above accepting a bribe in order to complete the more speedily a specific commission.

But Canaletto's real and most important contact with English patrons was through Joseph Smith, who, from 1744, was English Consul at Venice, but who had been an important art patron in the city for many years before that. His earliest contact with Canaletto was probably about 1729 and, like McSwiney before him, he found the artist difficult and mean: 'Nor is it the first time I have been glad to submit to a painter's impertinances to serve myself and friends,' he wrote in 1729. In fairness to Canaletto, however, it should be said that nothing which we know of Smith himself does anything to suggest that he, too, was other than difficult and mean; and Horace Walpole, who called him 'the Merchant of Venice', was not the only contemporary to suggest as much. It is not certain if Smith actually exclusively employed Canaletto for a period of years about the 1730s; but it is known that at this time almost all Canaletto's commissions came through Smith, who at the same time was retaining many of the artist's pictures for himself. In the 1760s when Smith sold many of his paintings to King George III there were among them at least 50 paintings and 142 drawings by Canaletto, and these are still in the Royal Collection. Patrons of Canaletto who early made use of Smith were Samuel Hill and Hugh Howard. In 1730 Smith wrote to Hill, 'At last I've got Canal under articles to finish your two pieces . . .' (Plate 32); and an account exists showing that Howard paid Smith directly for 'two pictures of Canaletti from Venice' (Plate 39).

At this time Canaletto painted, probably expressly for Smith, a series of twelve small pictures of views on the Grand Canal in Venice. These formed a sort of topographical record of the buildings lining the Grand Canal, a record to which Canaletto was to refer throughout his painting career. More importantly, such a commission from Smith (if that in fact was what it was) enlarged the range of the Venetian view-painter's work. Earlier painters such as Carlevaris—who was the most important influence on Canaletto—had limited their views of the city to the regatta on the Grand Canal and to the area neighbouring the Piazza San Marco: the Basilica, the Piazzetta and the Bacino. Now Canaletto looked beyond that and his views, because they were engraved (again probably at the instigation of Smith), were to have enormous influence on subsequent view-painters' work. To the twelve scenes on the Grand Canal the painter added two larger pictures of the *Bucintoro at the Molo* and the *Regatta on the Grand Canal* and all fourteen were engraved by Antonio Visentini and published in 1735 (Plates 13, 14) All the pictures for which these engravings were made were in Smith's collection and the project certainly dates from as early as 1730, when Smith wrote to Samuel Hill: 'The prints of the views and pictures of Venice will now soon be finished . . .' Later, in 1742 and 1751, expanded editions of the engravings were published; they included a further twenty-four views, again many of them of novel scenes, including several of the churches in the 'interior' of the city. Smith may also have commissioned Canaletto's etchings, the publication date of which is not known exactly, but they were dedicated to Smith, who by the time had become 'Consul of His Brittanic Majesty to the Most Serene Republic of Venice'.

Canaletto was not the first view or *vedute*

painter to work in Venice, and he was far from being the last. He was, however, the one such painter whose reputation depends almost exclusively upon his topographical scenes of that city. Carlevaris before him, and his contemporaries Michele Marieschi and Francesco Guardi, were among those who painted similar subject-matter; and the work of all three painters comes under consideration when discussing Canaletto.

The most important influence on Canaletto as a view-painter was undoubtedly Luca Carlevaris (1663-1730), a painter who settled in Venice in 1679 and who painted imaginary landscapes as well as real views of the city. Of these the most splendid, and the most important, were undoubtedly those which depicted the great Venetian festivals such as the regatta on the Grand Canal and the receptions of foreign dignitaries at the Ducal Palace. It was to such paintings as these (many of which were engraved) that Canaletto referred in his early work; and of the several paintings by him of regattas on the Grand Canal, all are based upon the view first adopted by Carlevaris about 1709 (Plate 8). Simple views of Venice by Carlevaris are confined to the Piazza San Marco and the Piazzetta; but in some of these the artist adopted a technique which was later employed by Canaletto (Plate 27). This involved showing a view which was much wider than anything one could possibly see at any one time. It is sometimes supposed that such pictures were painted with the aid of some form of lens; but as none of the buildings in these pictures are distorted it seems more likely that the views were in part imagined. As many of Carlevaris's views were engraved, and as he also published in 1703 a volume of etchings *Le Fabbriche e Vedute* . . . his compositions were freely available to be made use of by artists such as Canaletto, Marieschi and Guardi. Just as Canaletto referred to the work of Carlevaris,

so too in time did Marieschi and Guardi refer to the work of Canaletto himself. In a more general sense Canaletto probably also derived from Carlevaris the technique of painting figures on a large scale in the foregrounds of his paintings to set off the background view.

In addition to making use of the engraved work of other artists such as Carlevaris, Canaletto also painted from nature. In a letter of 1725 the painter and agent Alessandro Mareschini wrote to a patron that Canaletto worked on the spot and not '*a casa*' as did Carlevaris. Owen McSwiney also informed the Duke of Richmond in 1727 that Canaletto's 'excellence lyes in painting things which fall immediately under his eye'. It seems most likely that many of the pictures which Canaletto made on the spot were drawings which he later worked up in the studio into paintings. Some of his drawings too are more finished than others and must also have been completed at home. In his sketchbooks, now in the Accademia, Venice, and elsewhere, Canaletto has made detailed outline drawings of Venetian topography on successive pages. These are inscribed with colour notes and also the uses to which the individual buildings were put, such as fruit-seller, grocer or rag-and-bone shop. The artist almost certainly referred to these drawings in his studio and many of the more charming details of his paintings are the scenes of business life which these descriptions prompted in his imagination: a fruit stall here, a furniture maker's there or an antique stall elsewhere. Sometimes drawings of an entire composition exist which were used exactly for a painting (Plate 37). At other times details of staffage might be changed or the shape of the composition altered. Many of the details in Canaletto's paintings are so precisely delineated that it is generally assumed that he used some form of lens or camera as well as simple aids such as a ruler and compasses. Certainly it is some-

10

times possible to see lines of architecture which are so straight that the painter must have used a ruler; and it is even possible that he sometimes even used some form of nibbed pen when inserting lines on an oil-painting.

Zanetti gives the information that Canaletto used a '*camera ottica*' in painting his pictures. This device simply consists of a box with a ground glass top, a lens and a mirror. The view through the lens, which is in one side of the box, is reflected by the mirror, which is at an angle inside, through the ground glass top, and it is from there that the artist traces it. Such a box, inscribed on the top 'A Canal', is in the Correr Museum, Venice, and almost certainly belonged to the painter. However, it need not be imagined that Canaletto used it on every occasion or even frequently.

From surviving correspondence and occasional bills it is possible to gain some information as to what Canaletto charged for his paintings. The evidence shows that in the early years he raised his prices several times. In 1725 he charged 20 sequeens (then about £10) for one of the smaller canvases; by 1728 this price had become 22 sequeens and shortly thereafter it was raised to 30 sequeens. It was natural that the artist should raise his prices as his popularity increased, as we know it did, although, if we are to believe one of the letters which Owen McSwiney wrote to the Duke of Richmond, Canaletto was 'whimsical and vary's his prices every day: and he that has a mind to have any of his work, must not seem to be too fond of it, for he'l be ye worse treated for it, both in the price and the painting too.'

It was in the late 1720s and 1730s that the artist produced his best work. Much of it, such as the views on the Grand Canal, was done for Joseph Smith or else for other patrons who invariably contacted the painter through Smith. Some patrons commissioned whole groups of pictures, some only a pair, and

English patrons included Lord Leicester, Lord Fitzwilliam, Samuel Hill, Hugh Howard and, most spectacularly of all, the Duke of Bedford, who commissioned no fewer than twenty-four paintings from the artist about 1731/2. These hung at Bedford House in London from that time and are now at Woburn Abbey. From the 1730s many of the artist's pictures were engraved in England by engravers working in London.

Surprisingly there is little or no evidence as to the nature of Canaletto's studio. It is not known definitely if he employed assistants and if he did the extent to which they assisted in his paintings. There are an enormous number of surviving pictures called 'Canaletto'. The artist's working career was almost fifty years long, but even so one doubts if he can have painted single-handed all the pictures which seem of sufficient quality to be associated with him. As we know, he was not averse to varying the quality of his work, so it is possible that some pictures which seem weaker in quality than others were, in fact, painted in their entirety by the artist himself. Occasionally it is possible to recognize in a painting different painters at work, but all attempts at establishing precisely which other painters worked in Canaletto's studio have failed. The most likely collaborator-pupil was his nephew Bernardo Bellotto (1720-80), who was in his teens at the time that Canaletto was busiest in the 1730s, and he may well have trained and worked with his uncle during this period. It is also uncertain how often Canaletto's pictures were imitated by contemporary painters working in Venice in the hope of attracting some of his market. This inevitably must have happened although the names of such painters are unknown to us.

With the 1740s Canaletto's choice of subject-matter broadened. Finally, in 1746, he paid the first of several visits to England. Both these facts may have had the same cause: the

outbreak of war in Italy (the Wars of the Austrian Succession) meant that fewer English tourists travelled in that country and this in turn led to a reduction in the number of Canaletto's patrons. From this period date the paintings and drawings of Roman subjects and these the painter may well have executed in order to attract Italian patrons. There is reason to believe that the subject-matter may have been dictated, even at this stage, by Joseph Smith, who may well have wished to create work for the artist. Canaletto as a young man had visited Rome but there is no evidence to suggest that he paid a second visit at this stage. The Roman paintings are in all probability based upon drawings which he may have made almost twenty years previously, and he also referred to the engraved work of other artists. Thus his view of the Cordonata, the steps leading to Campidoglio, is based upon an engraving by Alessandro Specchi which was published in 1692 (Plate 76). In some of his *capricci* dating from this time, particularly the drawings, Canaletto also incorporates Roman motifs; and the view of *The Arch of Constantine* (Plate 35) is one of a group of paintings, all now at Windsor, which he painted for Joseph Smith and which the latter referred to as 'over-doors'.

That Canaletto was influenced by the wars in Italy in his decision to come to England is almost certain. This was stated by Vertue, 'of late few persons travel to Italy from hence during the wars'; he adds that the painter's visit was suggested to him by Jacopo Amigoni, a Venetian history painter who had had considerable success in England before returning to Venice. Vertue, who referred to Canaletto as 'a sober man turned of 50', also stressed how successful a painter Canaletto was and that being 'easy in his fortune' he had brought most of it with him to England to invest for better security. Canaletto also brought with him letters from Joseph Smith

to Owen McSwiney asking for an introduction to the Duke of Richmond, who, of course, already owned pictures by the artist. It was suggested to the duke, by his former tutor Tom Hill, that he might allow Canaletto to paint from the dining-room of Richmond House, the duke's London home. This is what happened, resulting in the superb pictures which are still in the collection of the Dukes of Richmond (Plates 48, 55). Soon Canaletto was patronized by Sir Hugh Smithson (later Duke of Northumberland), for whom he also painted views of London. Nevertheless, several pieces of evidence seem to show that the painter was not as successful in England as he might have hoped. His paintings of London seem not to have been all that popular, probably for the very same reason that the Venetians only very rarely bought his views of Venice; and he sought the patronage of country-house owners by painting views of their houses. In this way he worked for the Duke of Beaufort and Lord Brooke (Plate 60), as well as the Duke of Northumberland. Several engravers in London published engravings after his London paintings at the time when Canaletto was still working in England, suggesting that where a market for his paintings did not exist, there was one for prints after them. Also, on at least two occasions, in 1749 and again in 1751, the painter advertised himself in the London daily press: 'Signor Canaleto hereby invites any Gentleman that will be pleased to come to his house to see a picture done by him being a View of St. James's Park which he hopes may in some manner deserve their approbation any morning or afternoon at his lodgins Mr. Wiggan Cabinet maker in Silver Street Golden Square;' and, 'Signior Canaletto Gives Notice that he has painted the Representation of Chelsea College, Ranelagh House, and the River Thames, which if any Gentlemen and others are pleased to favour him with

seeing the same, he will attend at his Lodgings . . .'

The worst blow to the artist's popularity in England was the rumour that such was the quality of his English work that he was not in fact Canaletto, but an impostor. Vertue writing at the time says:

On the whole of him something is obscure or strange. He does not produce works so well done as those of Venice or other parts of Italy. which are in collections here. and done by him there. especially his figures in his works done here, are apparently much inferior to those done abroad. which are surprisingly well done & with great freedom and variety—his water & his skys are at no time excellent or with natural freedom. & what he has done here his prospects of Trees woods or handling or pencilling of that part not various nor so skillfull as might be expected. above all his is remarkable for reservedness & shyness in being seen at work, at any time, or anywhere. which has much strengthened a conjecture that he is not the veritable Cannelleti of Venice, whose works there have been bought at great prices. or that privately there, he has some unknown assistant in makeing or filling up his . . . works with figures.

It never occurred to the English that their own landscape might have had something to do with the apparent change in Canaletto's style. That, for example, a punt on the Thames was quite different from a gondola on the Grand Canal; that Warwick Castle, splendid though it was, could never appear as enchanting as the Palazzo Balbi or even the Rialto Bridge. The fact that English weather (then as now) was not remotely similar to the Venetian climate seems also to have escaped these eighteenth-century aristocratic patrons.

A precise date for Canaletto's return to Venice is not known although it was probably some time in 1756. He had, however, on at least two occasions visited Venice during the decade of his English period. These visits took place in 1750, for a period of about eight months, and again in 1753; but paintings exist which are inscribed by the painter on the reverse of the canvas 'fatto . . . in Londra' with dates 1754 and 1755.

Canaletto was almost sixty on his final return to Venice from England and was to live for a further twelve years or so. Not surprisingly relatively few paintings exist from this last decade and those views of Venice which do have a certain mechanical quality. It was in his last years that he was honoured by being elected a member of the Venetian Academy (which had been founded only in 1756 as a school for artists) and in the following year he was elected Prior of the Collegio dei Pittori. These were the simplest honours for there is little evidence to suggest that Canaletto, or any other view-painter, was ever taken seriously as an artist by his Venetian contemporaries. View-painting was scarcely considered an art at all in the city where worked at the same time as Canaletto, the Tiepolos, father and son, Pellegrini, Sebastiano Ricci, Piazzetta, Rosalba Carriera and Pietro Longhi. In Alessandro Longhi's *Compendio* of the lives of Venetian painters which was published in 1762, Canaletto, who was by then extremely famous, is nowhere mentioned, but this was the lot of the view-painter and Canaletto need not necessarily have resented it. Like his contemporaries he probably saw himself as a craftsman rather than as an artist, and the *vedute* which he painted as crafts rather than art.

Surprisingly Canaletto was not wealthy at the time of his death, and what fortune there existed was shared between his three sisters. He probably never married and his nephew, Bernardo Bellotto, who by 1768 had settled in Warsaw, was the only family heir to his artistic talents.

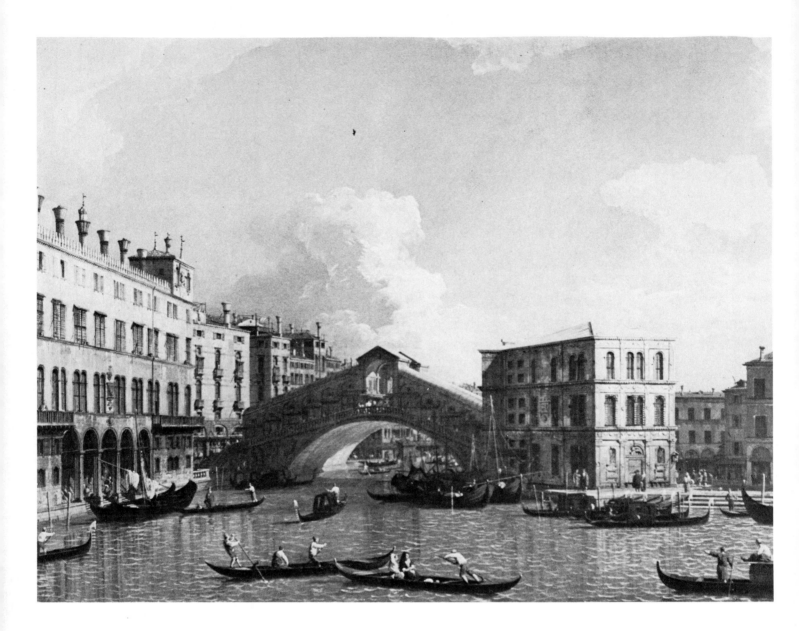

3. *Grand Canal: the Rialto Bridge from the North.*
Oil on copper, 46 × 58.5 cm. (18 × 23 in.). From
Goodwood House by courtesy of the Trustees.
This is one of the earliest known paintings by the artist
and was purchased from him by Owen McSwiney for
Lord March (later 2nd Duke of Richmond) in November
1727. In that month McSwiney wrote to Lord March
'I shall have a view of the Rialto Bridge, done by Canal
in twenty days . . .' In the same letter McSwiney wrote,
'The fellow (Canaletto) is whimsical and vary's his prices
every day; and he that has a mind to have any of his
work, must not seem to be too fond of it, for he'l be y^e
worse treated for it, both in the price and the painting
too. He has more work than he can doe.' This painting
is unusual in that it is painted on copper.

4. *The Stonemason's Yard.* Detail of Plate 6.

14

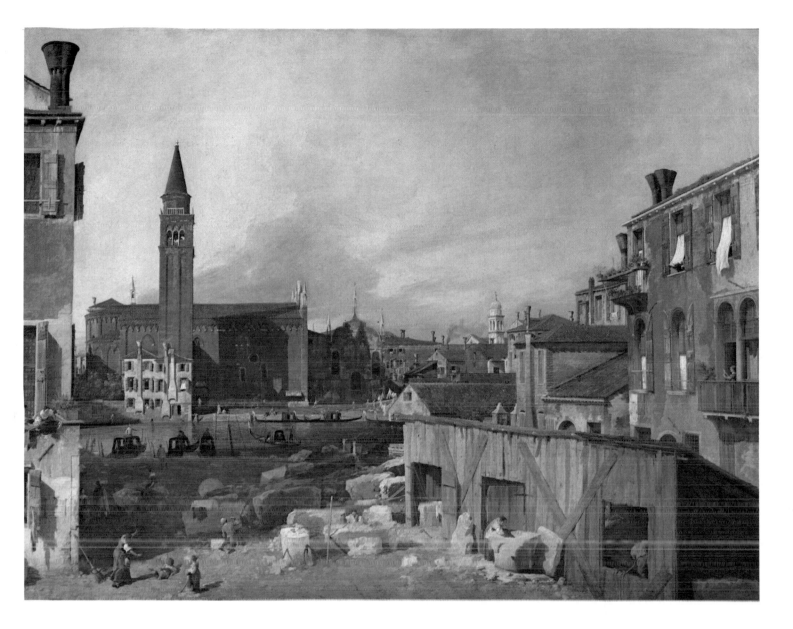

5 and 6. *Grand Canal: 'The Stonemason's Yard'; Sta
Maria della Carità from across the Grand Canal.* Canvas,
124 × 163 cm (48¾ × 64⅛ in.). London, National
Gallery.
'The Stonemason's Yard' is the affectionate, though quite
inaccurate, sobriquet for this most famous of Canalettos.
A stonemason's yard is never known to have existed at
the Campo S. Vitale, and the half-hewn stones are most
likely to have been there because of the rebuilding of the
church of S. Vitale in the first decades of the eighteenth
century. The picture was probably painted shortly before
1730; but it is first recorded in the early years of the
nineteenth century when it was in the collection of Sir
George Beaumont, who presented it to the National
Gallery upon its foundation in 1824. The appeal of the
picture lies in the fact that it is an unusual view, showing,
not the splendid 'façade' of Venice, but instead the daily
life of commonplace Venetians.

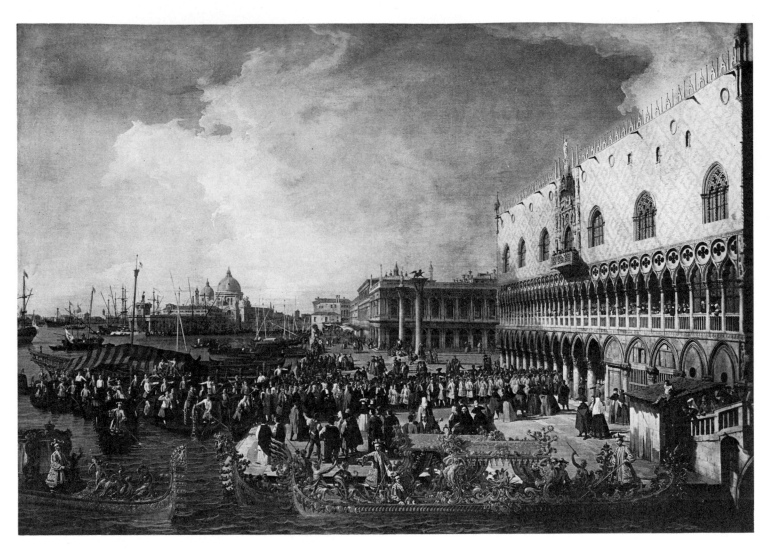

7. *Reception of the Imperial Ambassador, Count Giuseppe di Bolagno, at the Doge's Palace.* Canvas, 184 × 265 cm. (72⅜ × 104¼ in.). Private Collection.
It is recorded that this ambassador arrived in Venice and received his first audience at the Doge's Palace on 16 May 1729. This picture was probably painted shortly afterwards, and like other 'reception' pictures by Canaletto, its composition is based upon a type established by the earlier painter Carlevaris.

8. Carlevaris (1665-1731): *Reception of the Earl of Manchester at the Doge's Palace in 1707.* Canvas, 132 × 264 cm. (52 × 104 in.). Birmingham, City Art Gallery.

9. *Reception of the French Ambassador at the Doge's Palace.* Canvas, 181 × 259 cm. (71¼ × 102 in.). Leningrad, Hermitage.
The ambassador in question, who has just landed at the Molo (the quay in front of the Doge's Palace), is probably Comte Gergy, who was appointed in 1723 and who made a magnificent entry into Venice on 4 November 1726. He is seen surrounded by Venetian senators. Canaletto's picture was probably painted some years after the event (possibly in about 1730) and its composition is derived from paintings of similar scenes by Carlevaris (1665-1731): an example is the *Reception of the Earl of Manchester* now in Birmingham City Art Gallery (Plate 8). Canaletto would have known these Carlevaris paintings from engravings made after them.

18

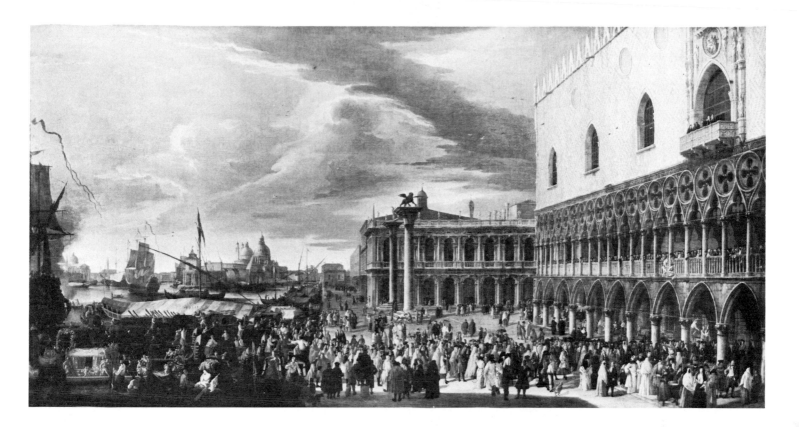

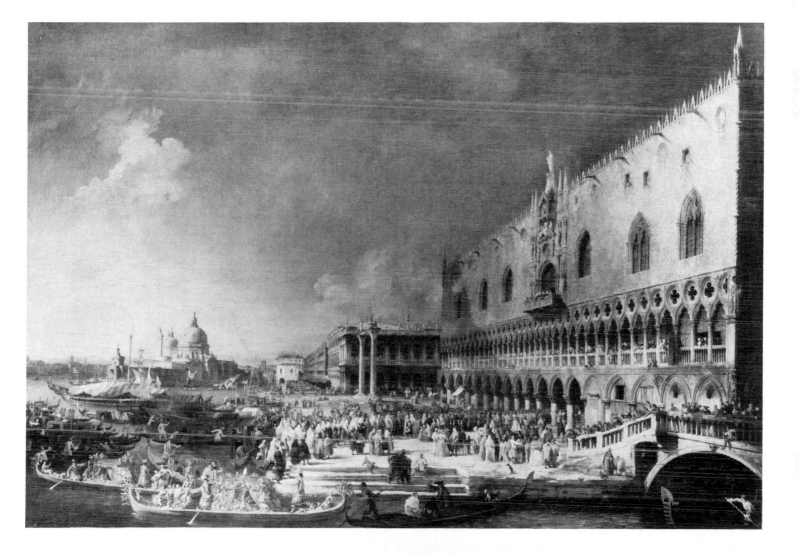

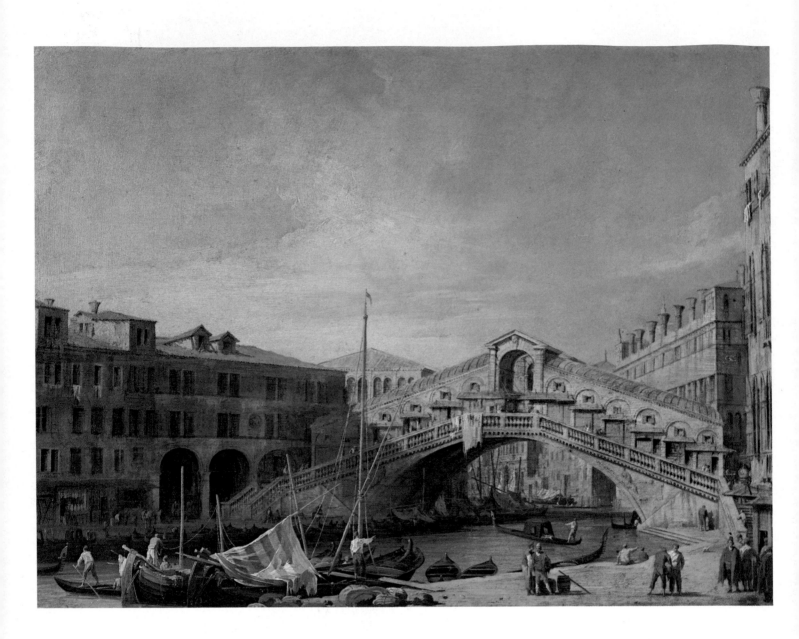

10. *Grand Canal: the Rialto Bridge from the South.*
Oil on copper, 45.5 × 62.5 cm. (18 × 24½ in.). Holkham
Hall, Earl of Leicester.
This picture, which is painted on copper, was probably
bought from the artist sometime before 1730 by the
Earl of Leicester. It was seen by Matthew Brettingham
in 1773 in the closet to the state bedchamber at Holkham.
The painting was engraved, together with five others by
Joseph Fletcher and published in London in 1739.

11. *The Piazzetta: Looking North.* Canvas, 170.2 × 129.5
cm. (67 × 51 in.). Windsor, H.M. The Queen.

20

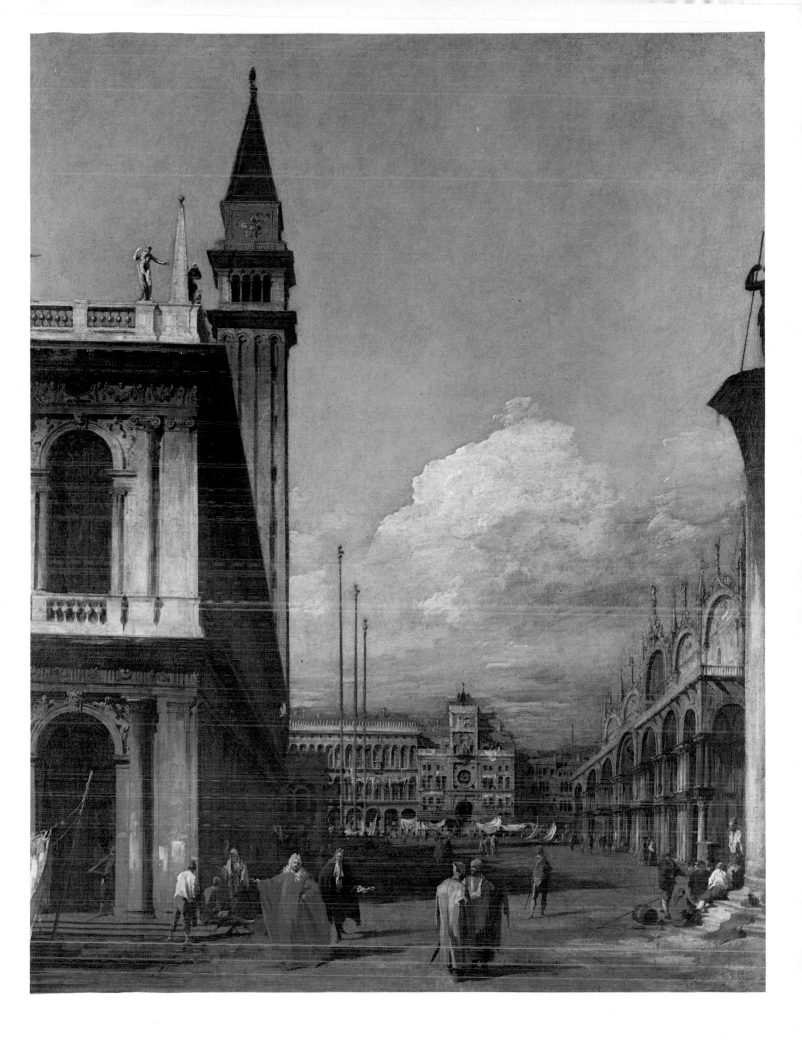

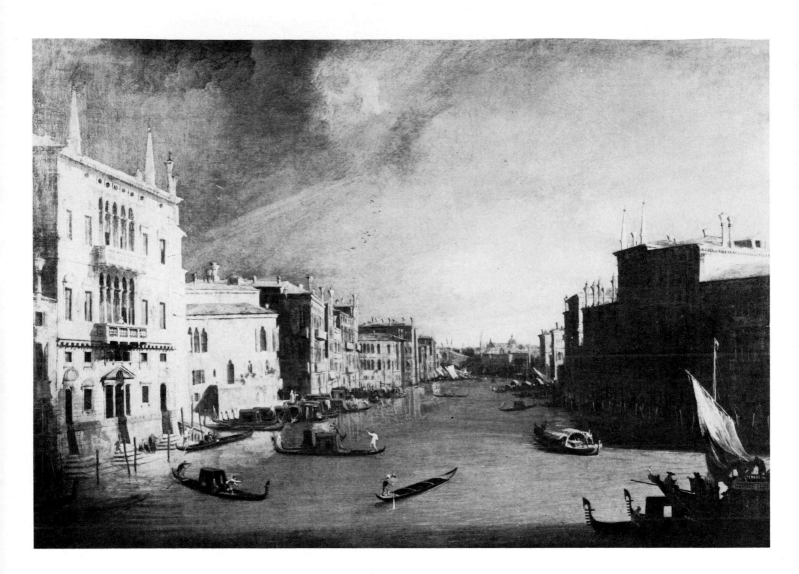

12. *Grand Canal: Looking North-East from the Palazzo Balbi to the Rialto Bridge.* Canvas, 65 × 96 cm. (25½ × 37¾ in.). Kingston-upon-Hull, Ferens Art Gallery.

This is an early painting by the artist and was probably painted about 1728. It is one of a group of pictures which were copied, probably in gouache, by a minor artist and fan-painter Joseph Baudin. Baudin's copies were engraved by a French engraver working in London, Louis-Philippe Boitard, and they were published (by Baudin) in 1736, only a year later than the first engravings after Canaletto (by Visentini) were published in Venice.

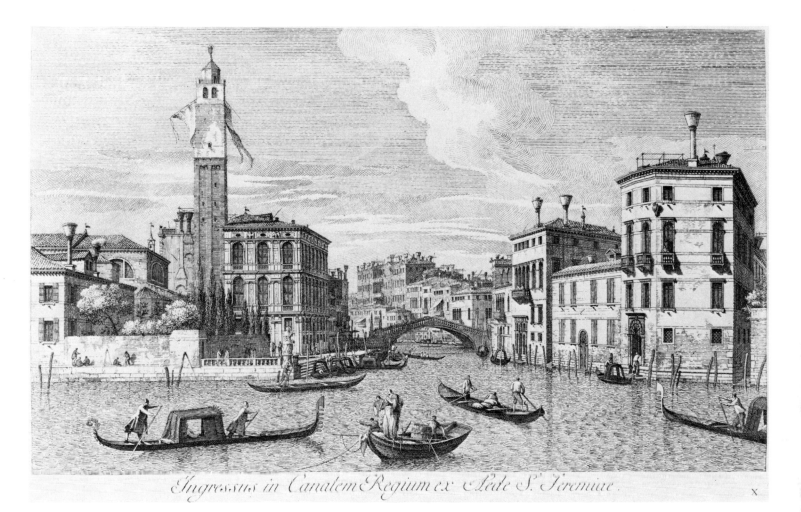

Ingressus in Canalem Regium ex Aede S. Ieremiae.

X

13. *Ingressus in Canalem Regium ex Aede S. Jeremiae.*
Engraving by Antonio Visentini (1688-1782). Published
1742. Oxford, Ashmolean Museum.
This is one of fourteen engravings after pictures by
Canaletto in the collection of Joseph Smith which were
published by Visentini first in 1735. The title of the series
was *Prospectus Magni Canalis Venetiarum* In 1742
and in 1751 the engravings were again published together
with additional plates.

14 (overleaf). *Grand Canal: S. Geremia and the Entrance
to the Cannaregio.* Canvas, 46.5 × 78.5 cm. (18¼ × 31 in.).
Windsor, H.M. The Queen.
This painting is one of several pictures by Canaletto
formerly owned by Consul Joseph Smith which were
bought by George III in the 1760s. It was engraved and
published by Visentini in 1735 and 1742. The painting
provides an interesting insight into the collaboration
between Canaletto, Smith and Visentini. The balustrade
and statue of S. Giovanni Nepumoceno in front of the
church were erected only in 1742 and are, therefore, of
necessity omitted from the 1735 engraving. Probably
some seven years after he had completed the picture,
Canaletto added them to it thereby bringing the painting
up to date.

23

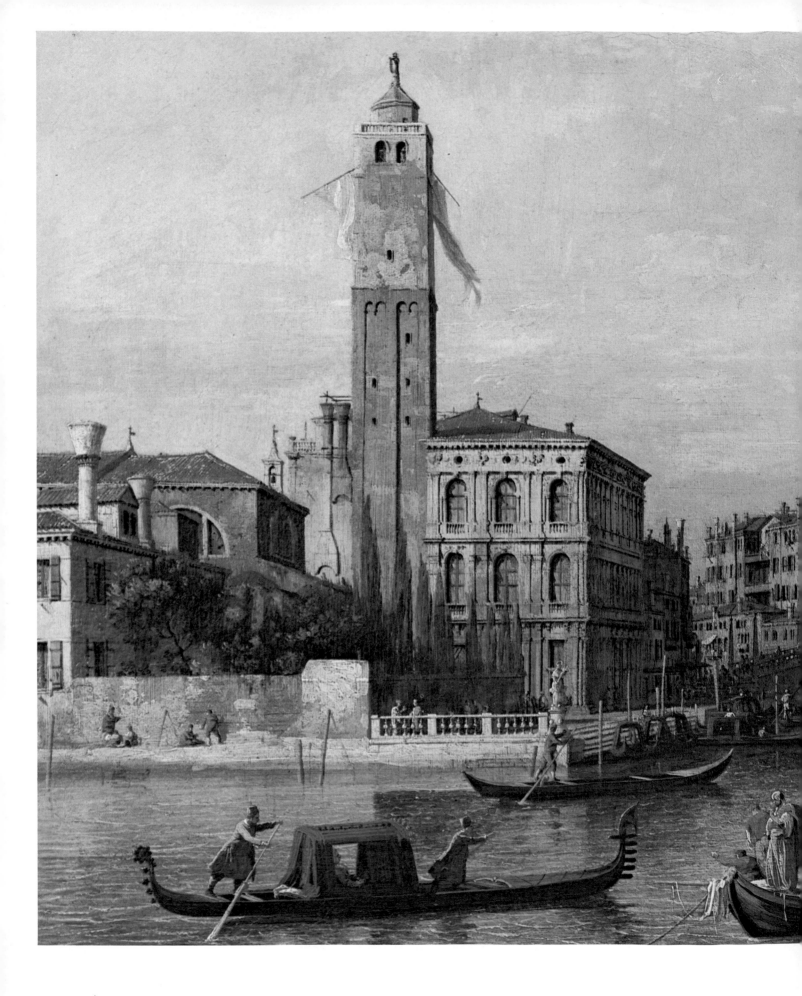

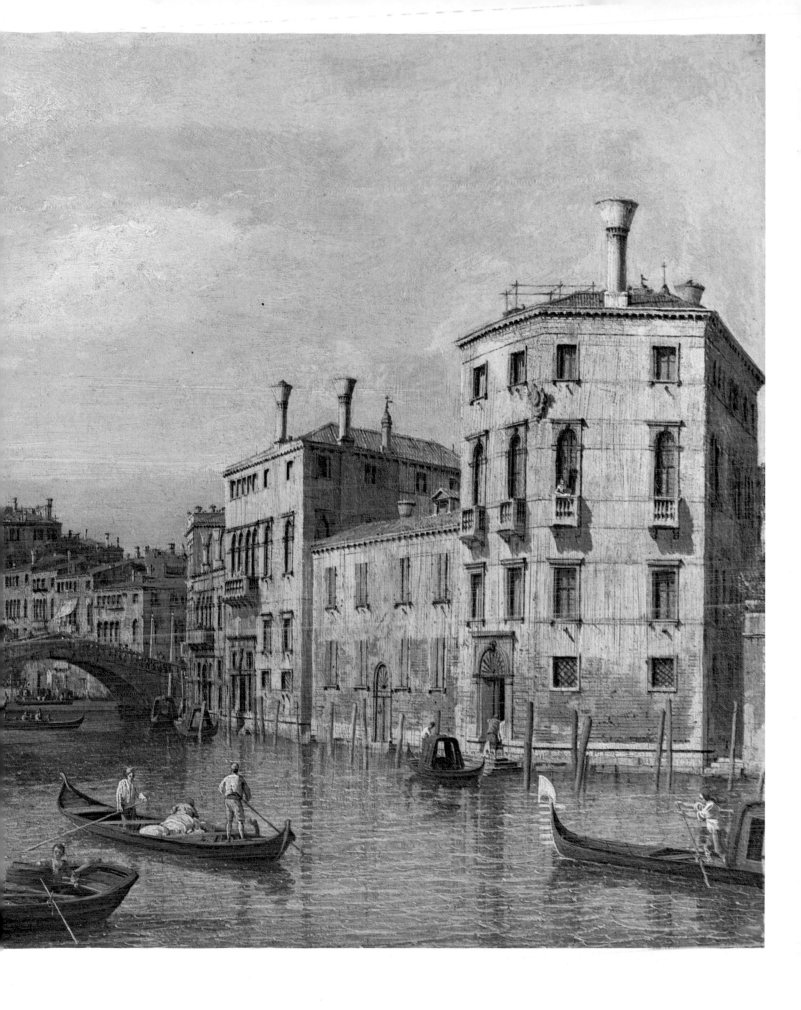

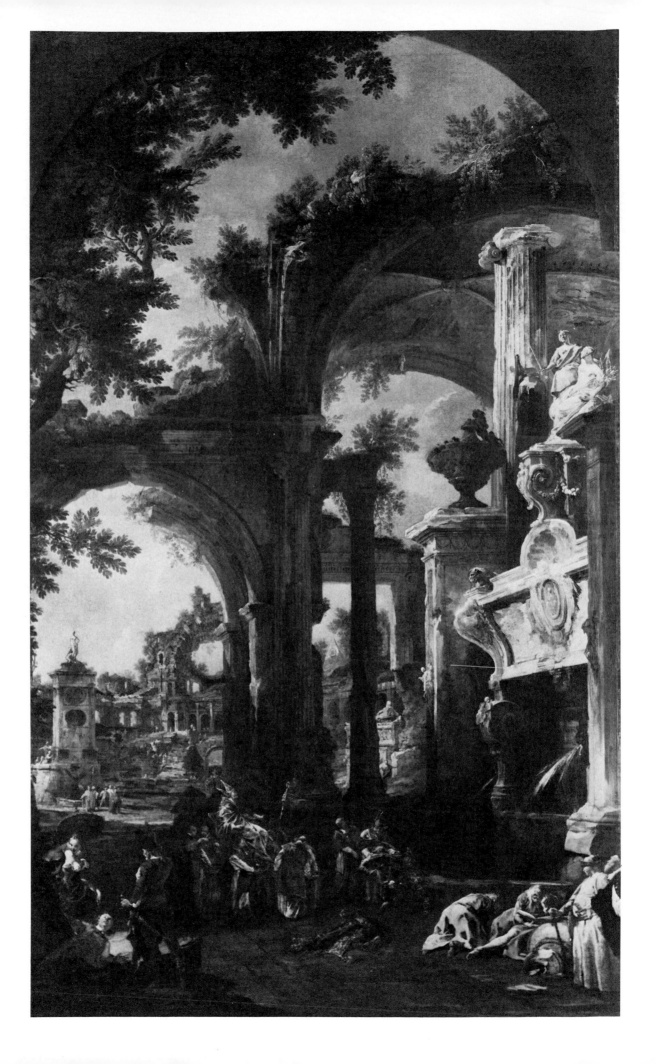

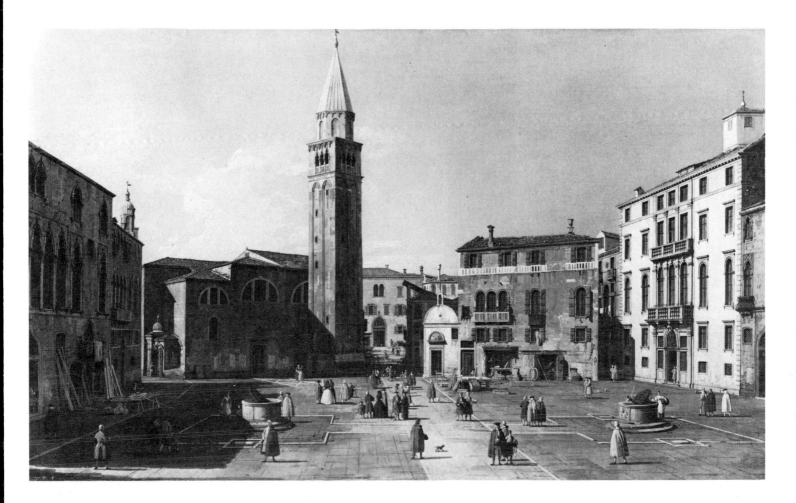

15. Canaletto, G.B. Cimaroli and G.B. Piazzetta·
*Capriccio Tomb of Lord Somers, with Ruins and a
Landscape.* Canvas, 279.4 × 142. 2 cm. (110 × 56 in.).
Earl of Plymouth.

This is one of twenty-four allegorical pictures painted in
celebration of the lives of recently-dead Englishmen.
They were commissioned of Venetian and Bolognese
painters by Owen McSwiney in the 1720s. This painting
was completed by 1722 as it is mentioned in a letter
from McSwiney to Lord March in that year, and the
same letter gives the information that it was painted by
Canaletto, Cimaroli and Piazzetta. The figures are by
Piazzetta, and the landscape was divided between
Canaletto and Cimaroli. All the pictures in the series
contained an urn 'wherein is supposed to be deposited
the Remains of the Deceased Hero'. Surrounding statues
and reliefs allude to the virtues of the deceased. In the
case of Lord Somers these are (above) Justice and Peace,
while a bishop and other ecclesiastics are shown paying
homage. As Lord Somers was Lord Chancellor of
England from 1697-1700 the mace, woolsack and Lord
Chancellor's purse are shown on the ground before his
tomb.

16. *Campo S. Angelo* Canvas, 46.5 × 77.5 cm. (18½ ×
30½ in.). New York, Private Collection.

This view remains more or less the same today, except
that the church of the Archangel Michael at the far side
of the square was demolished in the nineteenth century.
In his views of the 'interior' of Venice Canaletto subtly
conveyed much of the atmosphere of Venetian life. Two
furniture-makers' shops are visible and also what seems
to be an antique market selling chairs and paintings at
the base of the Campanile, while figures passing through
linger awhile to gossip.

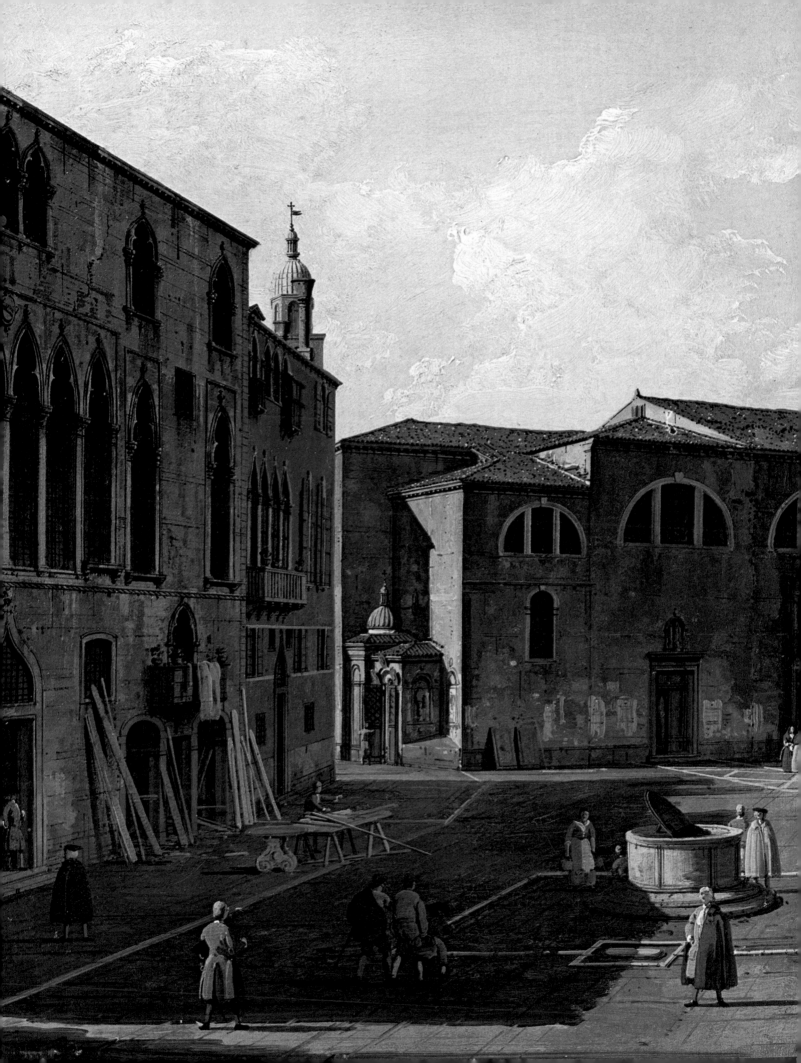

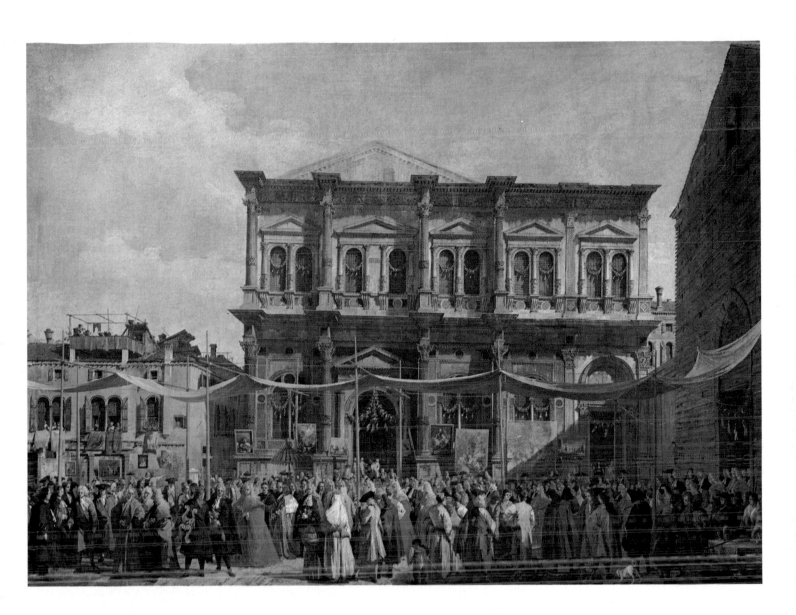

17. *Campo S. Angelo*. Detail of Plate 16.

18 (and details 19, 20 overleaf). *The Doge Visiting the Church and Scuola di S. Rocco*. Canvas, 147 × 199 cm. (58 × 78½ in.). London, National Gallery.
The scene is shown as taking place in the Campo S. Rocco with the Scuola in the background. The Doge attended mass annually on the feast day of S. Rocco (August 16) in the church of that name. He was accompanied by senators (leaving the church in scarlet robes), other officers of state and ambassadors. The Scuola is decorated with pictures as was customary on the feast day. Plates 19 and 20 show details of this painting.

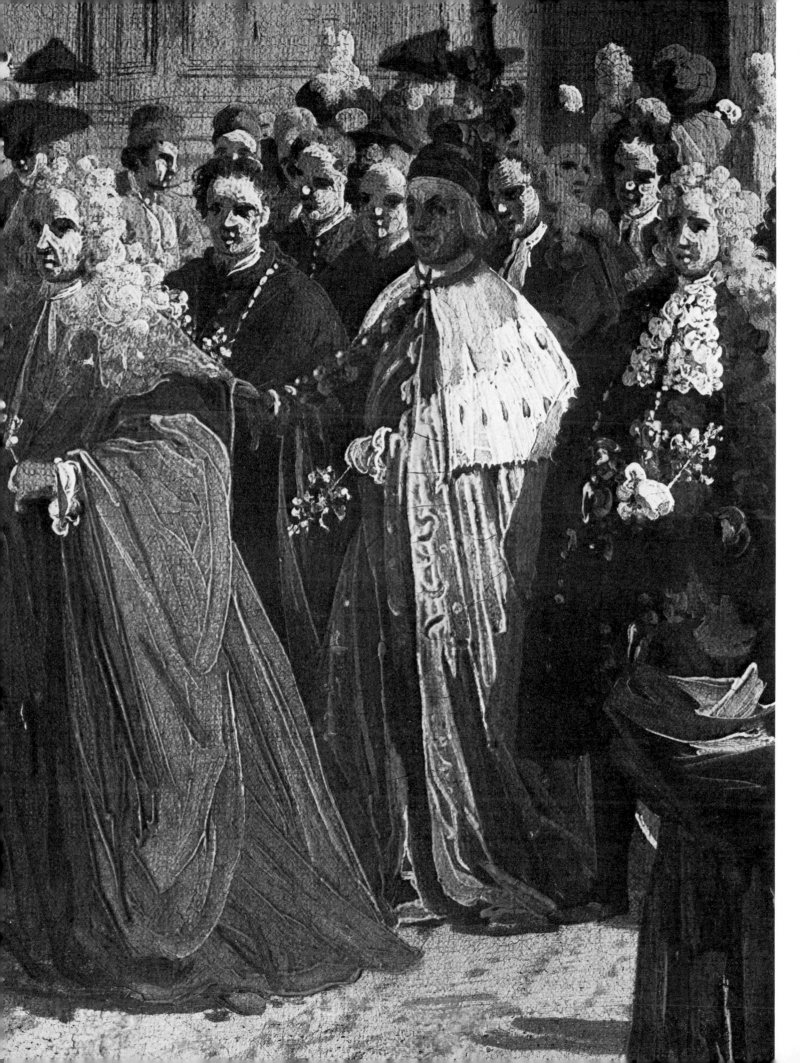

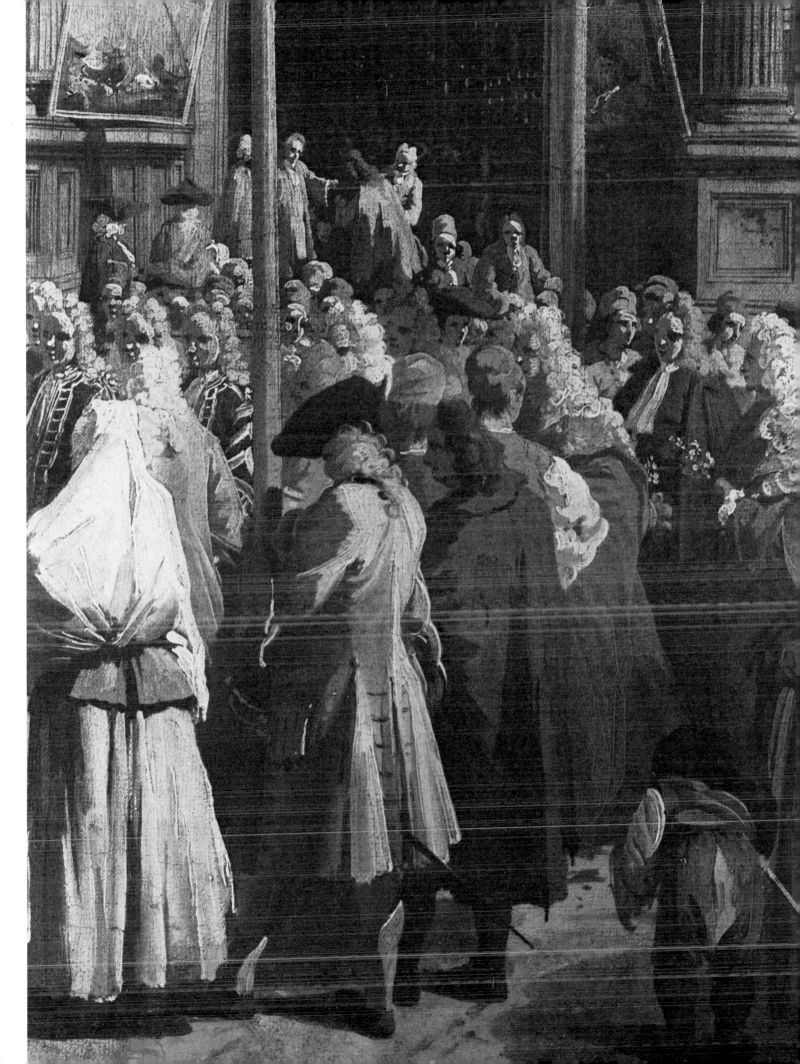

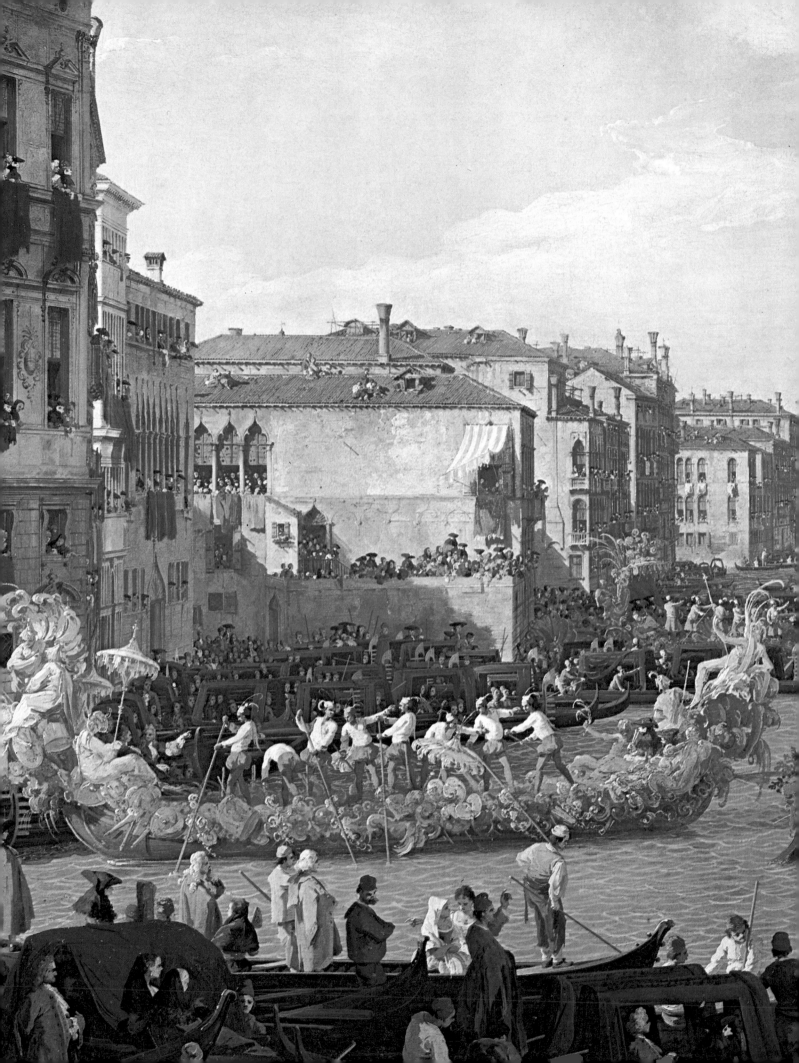

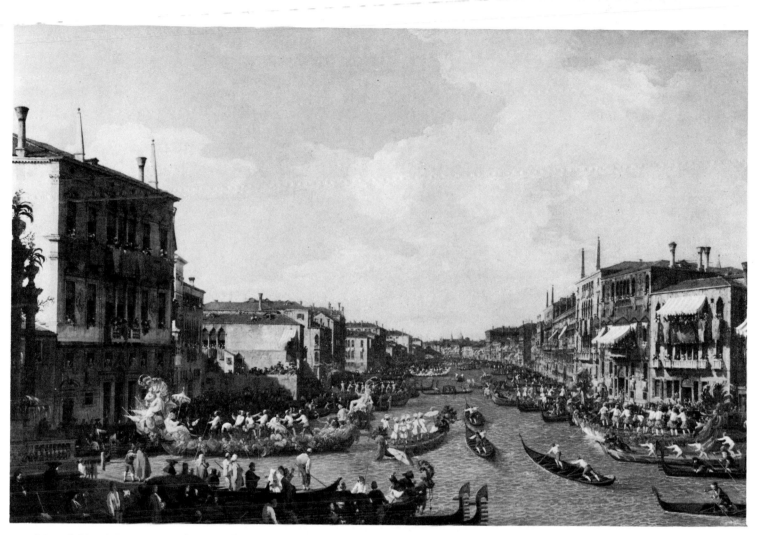

21 and 22. *A Regatta on the Grand Canal*. Canvas, 150 × 218 cm. (59 × 86 in.). Barnard Castle, Bowes Museum
(on loan from a Private Collection).

The view is similar to that in Plate 12 but this painting shows the temporary *macchina della regatta* to the left of
the Palazzo Balbi. It was from this structure that winners in the regatta were awarded their prizes. The regatta shown
is that which took place annually during the carnival: several of the figures are wearing the *bauta*, a domino of white
mask and black cape worn only during carnival times. Canaletto painted several similar regatta pictures and he seems
to have derived his composition from a painting of the regatta of 1709 by Carlevaris.

23. *Composite photograph of four pages from a Canaletto sketchbook showing buildings on the Grand Canal between
the Palazzo Corner and the Palazzo Contarini*. Venice, Accademia Museum.

These diagrammatic drawings are most likely to have been made by Canaletto on the spot by way of recording
buildings and topography which he later used in paintings and more finished drawings. The drawings are executed
for the most part in chalk and ink, and on many of them Canaletto has described the type and colours of the various
buildings. The drawings may well have been made over a period of time, probably in the 1730s. See Plate 37.

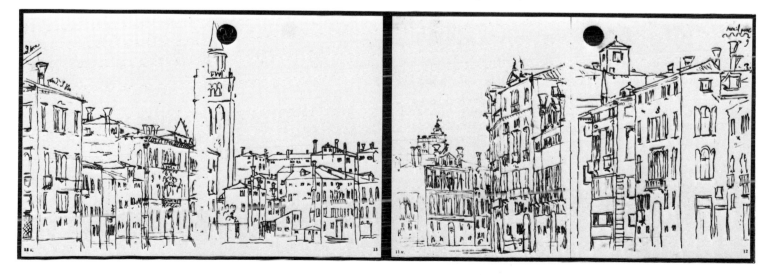

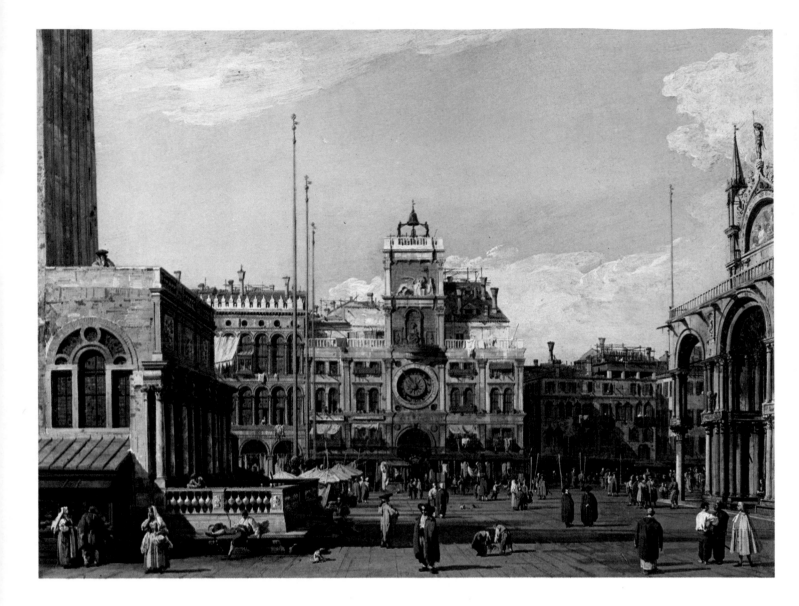

24. *Piazza S. Marco: Looking North.* Canvas, 53 ×
70.5 cm. (20⅛ × 27¾ in.). Kansas City, William Rockhill
Nelson Gallery of Art.
In the centre of the picture is the Torre dell' Orologio
with the Loggetta at the base of the campanile on the
left. The picture was engraved by Henry Fletcher and
published in London in 1739.

25. *The Bucintoro Preparing to Leave the Molo on
Ascension Day.* Detail of Plate 26.

34

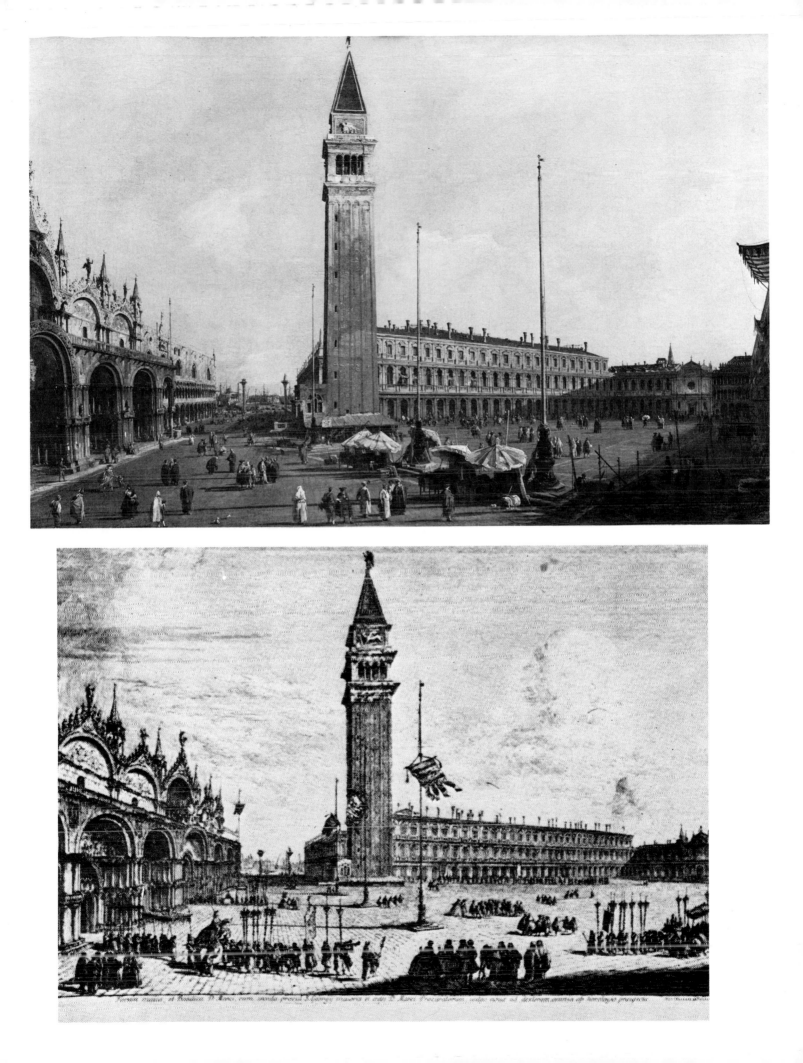

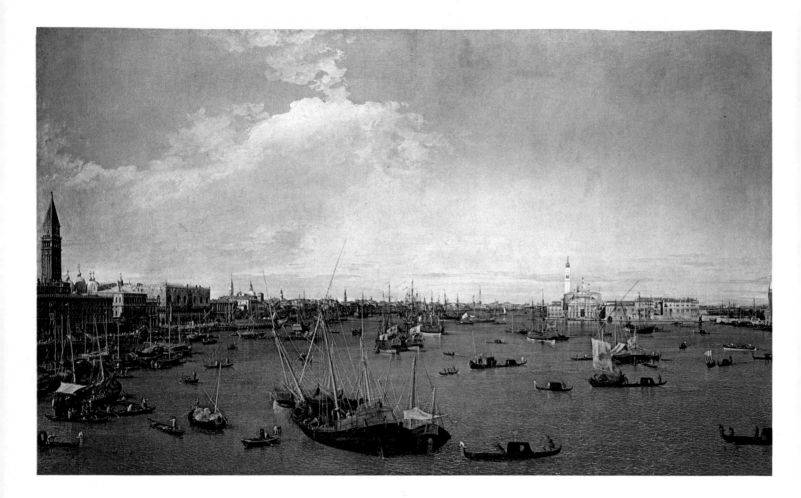

29. *The Bacino di S. Marco: Looking East*. Canvas, 125 × 153 cm. (49⅛ × 60¼ in.). Boston, Museum of Fine Arts.

The Molo and the Riva degli Schiavoni are on the left and the island and church of S. Giorgio Maggiore to the right in the middle distance. Several of the flags on the various ships in the Bacino are identifiable. They include those of England, France, Denmark and Venice. The panoramic view is taken from two viewpoints, the left-hand side of the picture is as seen from the Punta di Dogana, whereas the right-hand side is painted from a point, across the entrance to the Grand Canal, on the Fonteghetto della Farina.

30. *Sta Maria Zobenigo*. Detail of Plate 31.

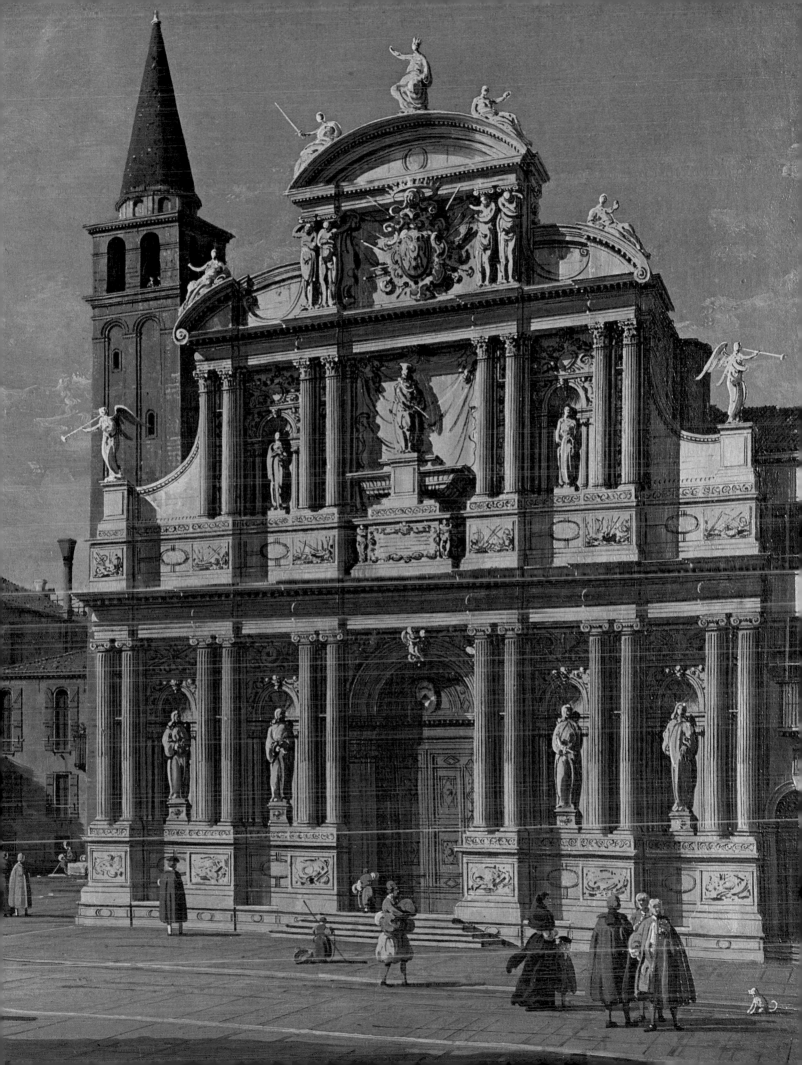

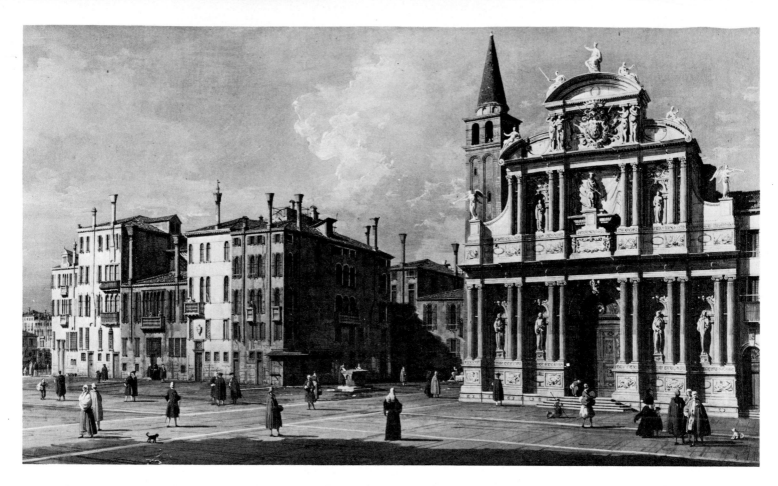

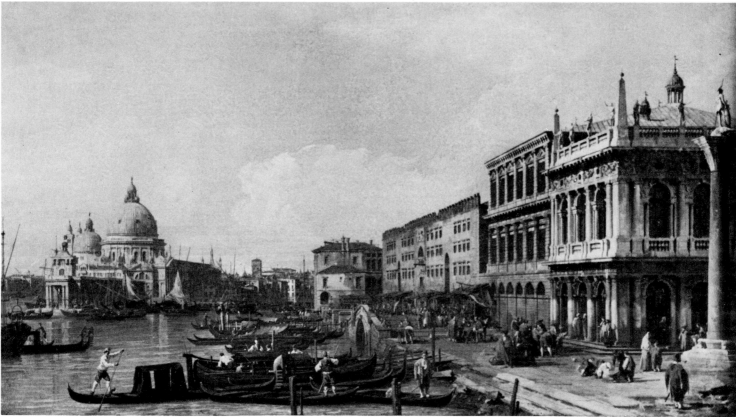

40

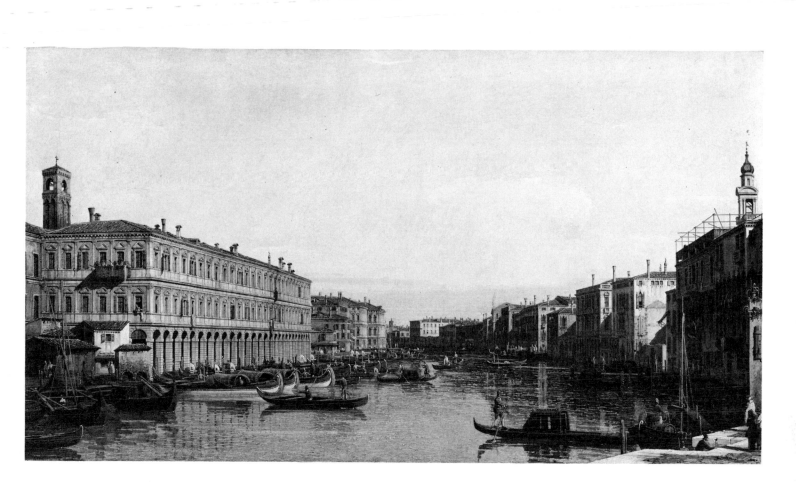

31. *Sta Maria Zobenigo*. Canvas, 47 × 78 cm. (18½ × 30¾ in.). New York, Private Collection.
This wide-angle view is one of twenty one paintings similar in size said to have been bought in Venice in the nineteenth century by the last Duke of Buckingham and Chandos. It is one of the paintings engraved in the second edition (1742) of Visentini's engravings.

32. *The Molo: Looking West with the Library to the Right*. Canvas, 58.5 × 102 cm. (23 × 40 in.). Tatton Park, National Trust.
This picture was purchased from the artist, through Consul Joseph Smith by Samuel Hill in 1730. In July of that year Smith wrote to Hill, 'At last I've got Canal under articles to finish your 2 pieces within a twelve-month,' and in December Samuel Hill's nephew wrote to him that Smith 'had att last prevailed with Canal to lay aside all other business till he had finished the 2 pictures you order'd when you were last here'. On the extreme right is the Column of S. Theodore; on the left the Dogana and Baldassare Longhena's church of Sta Maria della Salute.

33. *Grand Canal: Looking North from near the Rialto Bridge*. Canvas, 73 × 128 cm. (28¾ × 50⅜ in.). Cologne, Wallraf-Richartz Museum.
There are several versions of this view by Canaletto, but this one differs from the others in that it shows the present Palazzo Mangilli-Valmarana fourth from right (which was owned by Joseph Smith) demolished prior to rebuilding. Its new façade was designed by Visentini and not completed until 1751. In the version of the view at Windsor, which was painted before 1735, Canaletto repainted at a later date that area of the picture showing the new palace.

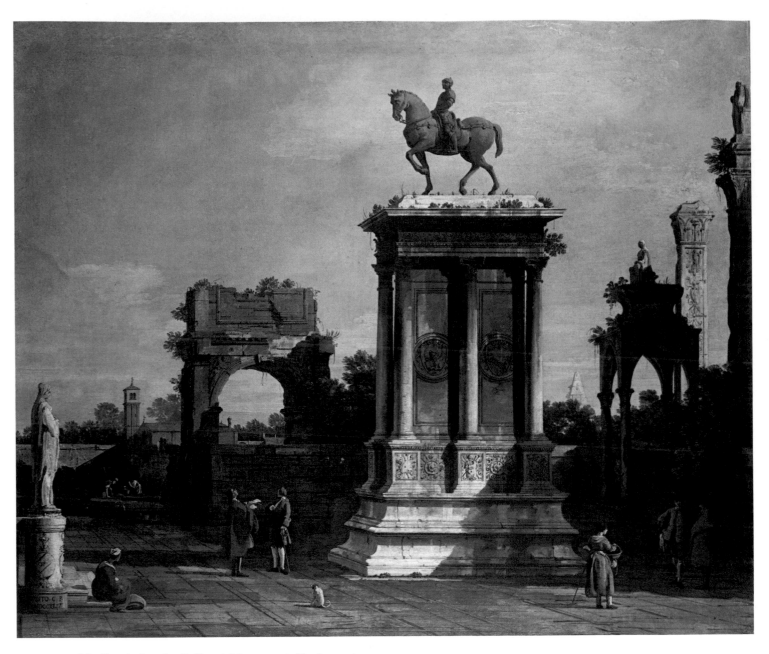

34. *Capriccio: the Colleoni Monument, Venice, set among Ruins.* Canvas, 107.5 × 129.5 cm. (42¼ × 51 in.). Windsor, H.M. The Queen.

The picture is signed and dated on the pedestal of the statue on the left: *Anto C. F. MDCCXLIV.* The equestrian monument to Bartolomeo Colleoni by the great Florentine renaissance sculptor, Andrea Verrocchio (1435-88), in fact stands in the square outside the church of S. Giovanni e Paolo. In Canaletto's picture it is made to stand among ruins reminiscent of antiquity. The picture was painted as an over-door and described as such by Joseph Smith at a time when it was in his collection.

35. *The Arch of Constantine, Rome.* Canvas, 181.5 × 103 cm. (71½ × 40½ in.). Windsor, H.M. The Queen. This picture, signed and dated 1742, is one of several Roman subjects which the artist painted in the 1740s. In 1719 Canaletto paid a visit to Rome where he painted stage scenery; but there is no evidence that he ever returned there. These later Roman views may have been painted from the engraved work of other artists.

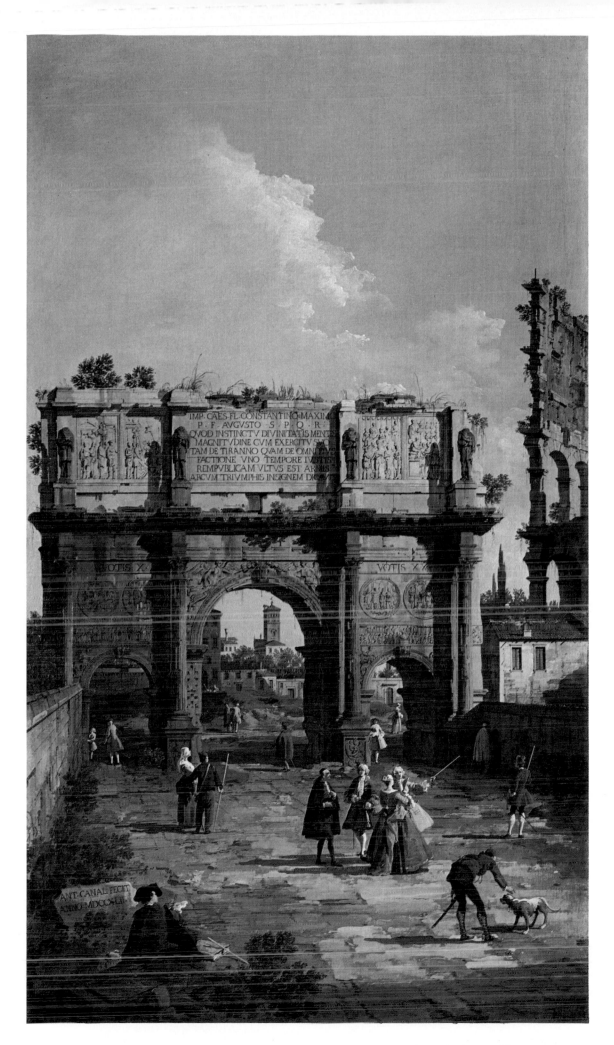

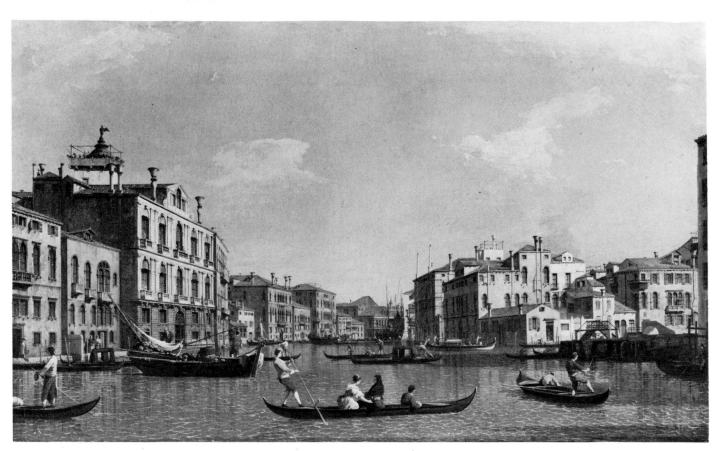

36. *Grand Canal: Looking North, from the Palazzo Contarini dăgli Scrigni to the Palazzo Rezzonico.* Canvas, 47 × 80 cm. (18½ × 31½ in.). Woburn Abbey, by kind permission of the Marquess of Tavistock and the Trustees of the Bedford Estates.

This is one of a group of twenty-four paintings which were painted by Canaletto probably about 1730 for the 4th Duke of Bedford. Since 1800 they have hung in the dining room at Woburn Abbey. The buildings in the picture were recorded by the artist, in a sketchbook now in the Accademia Museum, Venice; and there is a complete drawing of the scene at Windsor.

37. *Grand Canal: Looking North-West, from the Palazzo Corner to the Palazzo Contarini dagli Scrigni.* Pen and ink over pencil, 26.7 × 37.4 cm. (10½ × 14½ in.). Windsor, H.M. The Queen.

The campanile in the distance is that of the church of the Carità, which is also visible, across the canal, in *The Stone-mason's Yard* (Plate 6). As this campanile collapsed in 1741 the drawing must have been made before that date.

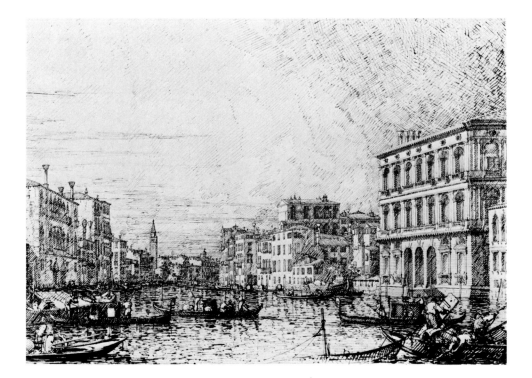

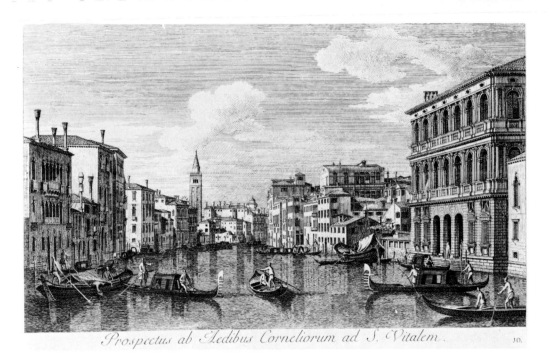

Prospectus ab Aedibus Corneliorum ad S. Vitalem. 10.

38. *Prospectus ab Aedibus Corneliorum ad S. Vitalem.* Engraving by Visentini after Canaletto, published in 1742. Oxford, Ashmolean Museum.

39. *Entrance to the Grand Canal: Looking West.* Canvas, 49.5 × 72.5 cm. (19½ × 28½ in.). Houston, Texas, Museum of Fine Arts.
The church on the left is Sta Maria della Salute. This picture was bought from the painter through Joseph Smith in 1730 by Hugh Howard. Howard was an ancestor of the Earls of Wicklow. In an account for August 22 of that year is listed 'Recd two pictures of Canaletti from Venice/Pd Mr Smith Mercht 35 Venn. Zecni, Value £18. 7. 11.' Both pictures remained in the collection of the Earls of Wicklow until the 1950s.

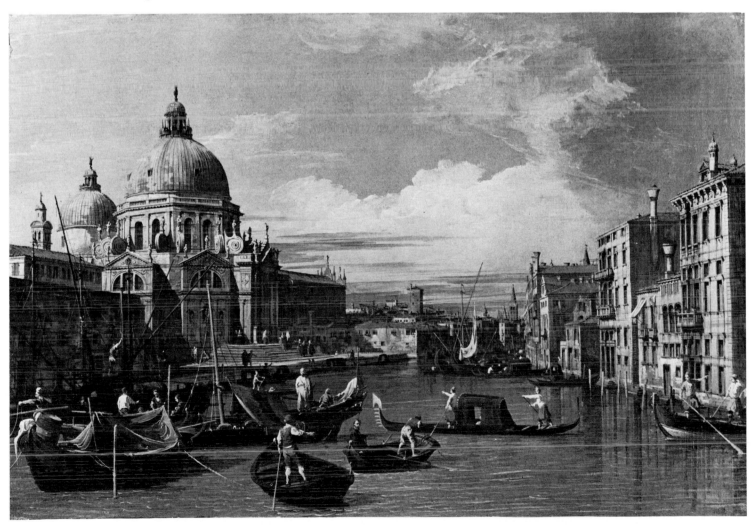

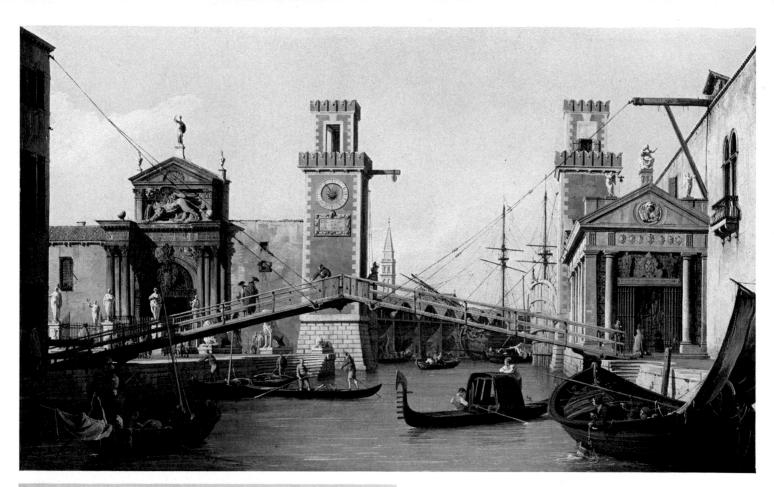

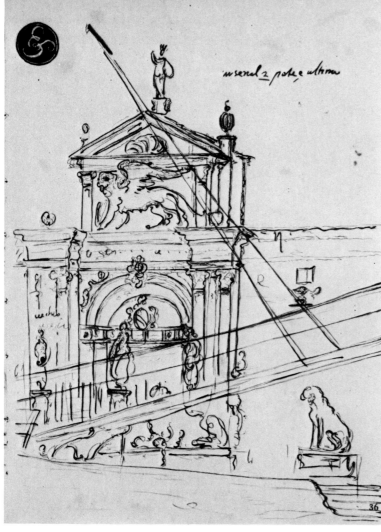

40. *Venice, the Arsenal: the Water Entrance*. Canvas, 47 × 78.8 cm. (18½ × 31 in.). Woburn Abbey, by kind permission of the Marquess of Tavistock and the Trustees of the Bedford Estates.

On the left is the great gate of the arsenal, on the right the former oratory of the Madonna dell'Arsenale. The arsenal dates traditionally from 1104. In the periods of greatest Venetian prosperity it employed over 16,000 workmen and it was from there that Venice's powerful trading and naval fleets set out.

41. *The Great Gate of the Arsenal*. 22.9 × 16.5 cm. (9 × 6½ in.). Venice, Accademia.

This drawing was very possibly made on the spot and probably served as a reminder to the artist when he later painted a view of the entrance to the arsenal.

42. *S. Giacomo di Rialto*. Detail of Plate 46.

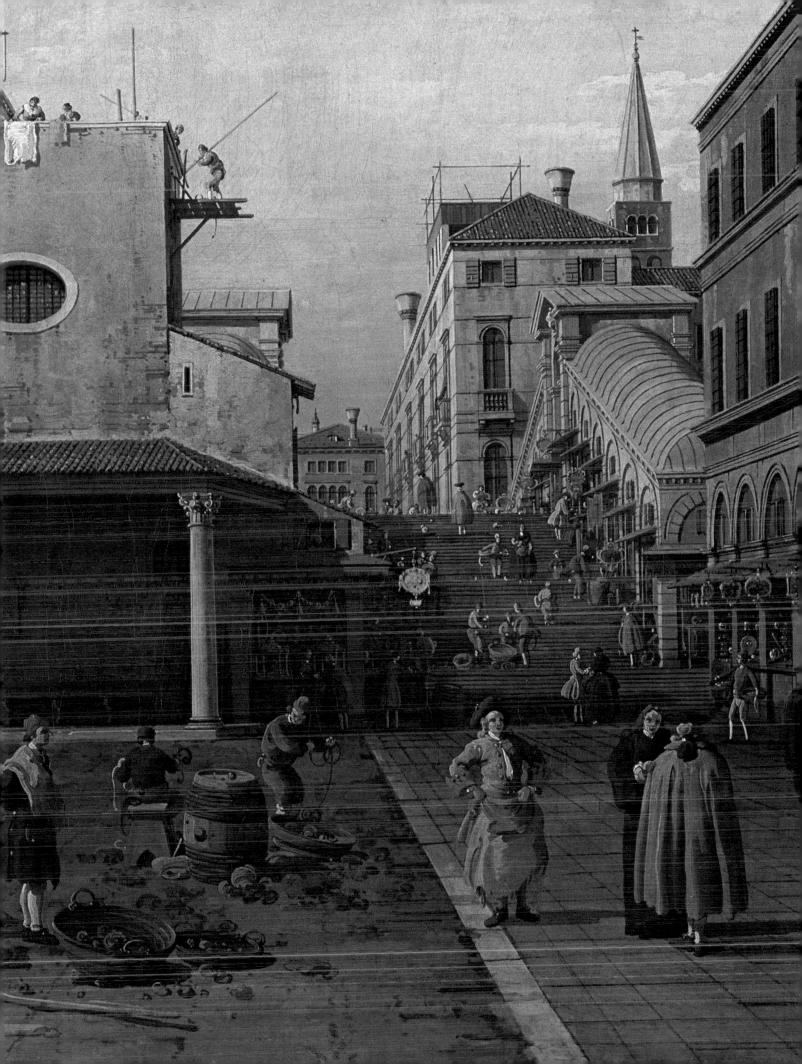

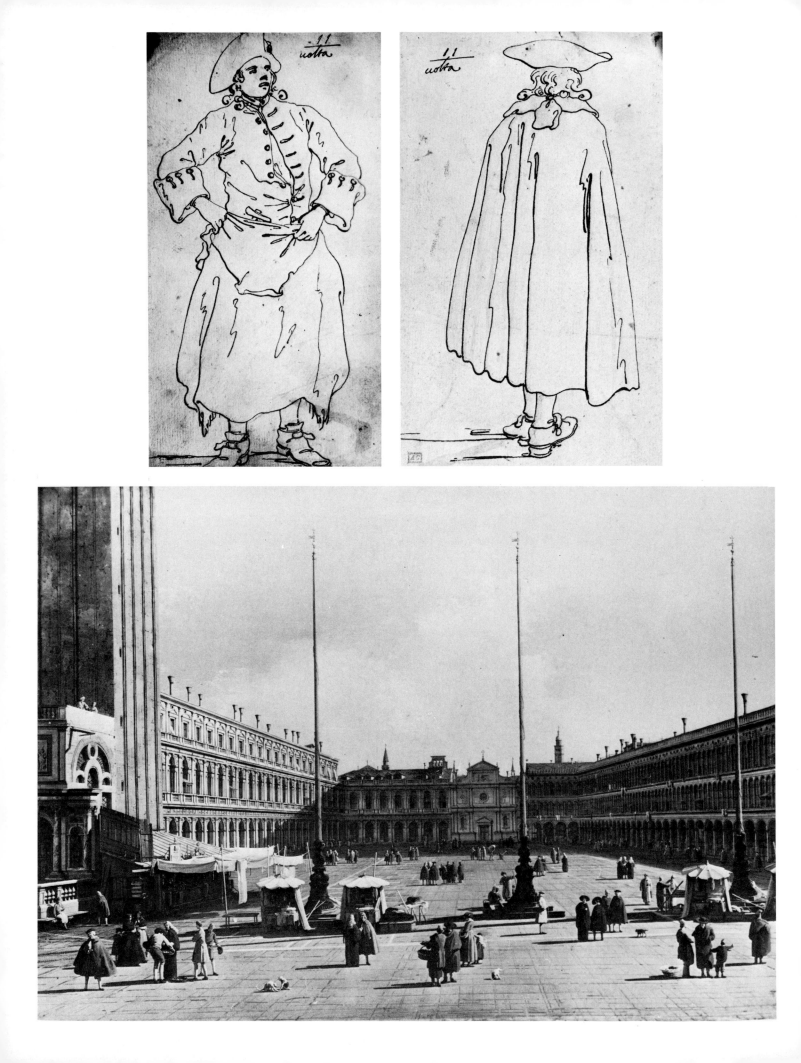

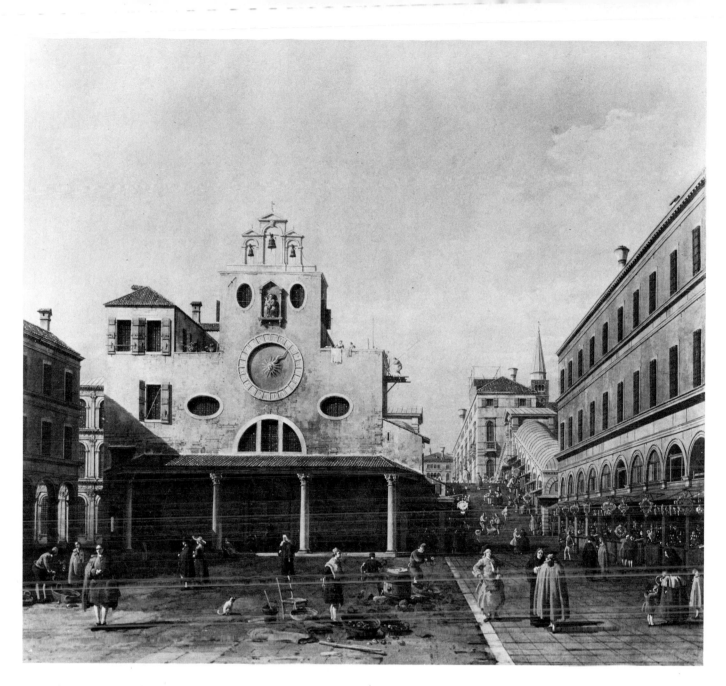

43 and 44. *Two Studies of Men Standing.* Pen and ink, 30.2 × 17.5 cm. (11⅞ × 6⅞ in.). London, Courtauld Institute of Art.

These two drawings are for the figures seen in the painting of S. Giacomo di Rialto (Plate 46) now in Canada.

45. *Piazza S. Marco: Looking West along the Central Line.* Canvas, 73.8 × 104.5 cm. (29 × 41⅛ in.). Milton Park, Earl Fitzwilliam.

This view of the Piazza S. Marco, looking from the basilica of S. Marco towards the church of S. Geminiano, was painted before 1742 as it was engraved by Visentini in that year. As the engraving was part of a set dedicated to Consul Joseph Smith, the painting may have been owned by him at that time. It was possibly bought by the 2nd Earl Fitzwilliam on the Grand Tour in 1766-8.

46. *S. Giacomo di Rialto.* Canvas, 118.7 × 129 cm. (46¾ × 50¾ in.). Ottawa, National Gallery of Canada. The church in the painting, which was originally built in the fifth century, is traditionally believed to be the oldest in Venice. Although Canaletto painted other views of it, here he has rather curiously shown the porch as having only four (instead of five) columns. The view to the right is across the Rialto Bridge. The painting was probably painted shortly after Canaletto's return from England in 1756.

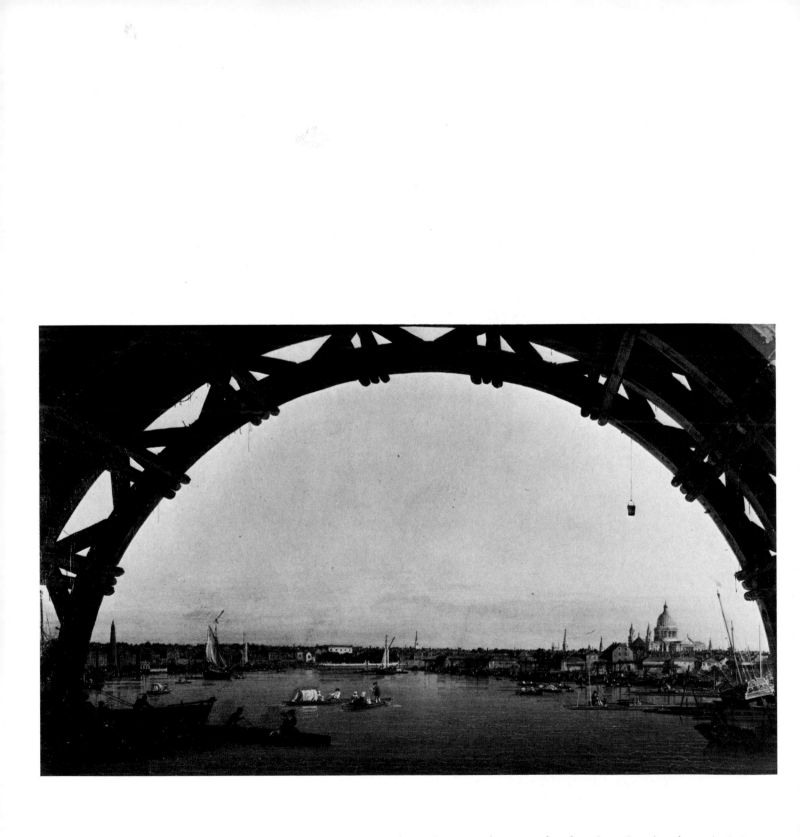

47. *London: Seen through an Arch of Westminster Bridge.*
Canvas, 57 × 95 cm. (22½ × 37½ in.). Duke of North-
umberland.

The bridge is shown as still under construction, but as
it was completed in July 1746, the painting must have
been made very shortly after Canaletto's arrival in
London in May of that year. Canaletto was already very
well known to the English before he came to England
and it is thought most likely that he came here because
few English tourists went to Venice in the later 1740s on
account of the War of the Austrian Succession in Italy.

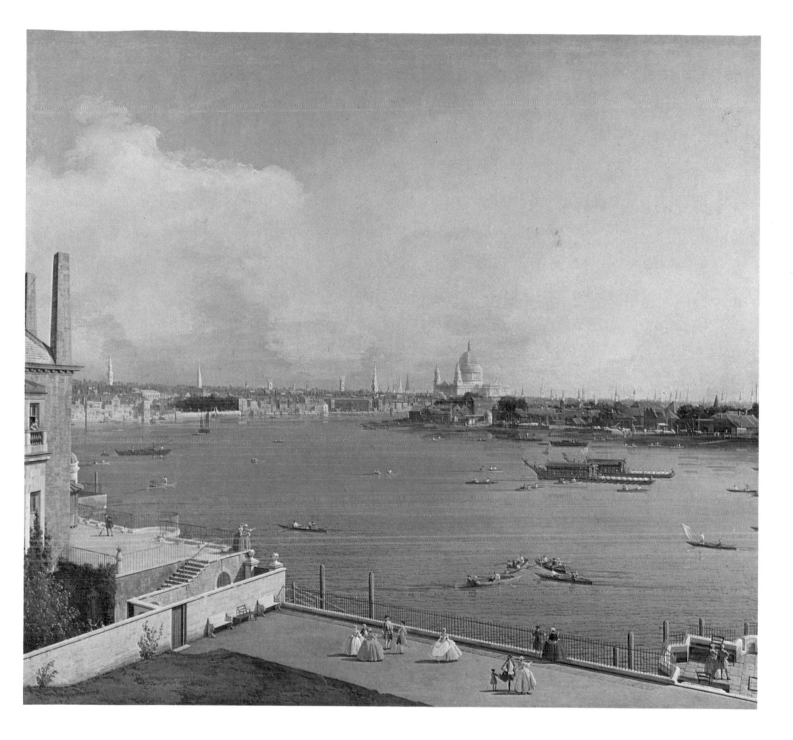

48. *London: the Thames and the City of London from Richmond House.* Canvas, 105 × 117.5 cm. (41¾ × 46¼ in.). From Goodwood House by courtesy of the Trustees.

In the distance is St Paul's Cathedral. Canaletto first visited England in May 1746, and this picture may be the earliest which he painted after his arrival. In a letter of May 20 the former tutor of Lord March wrote to him: 'I told him (Canaletto) the best service I thought yo could do him w^d be to let him draw a view of the river from y^r dining-room.'

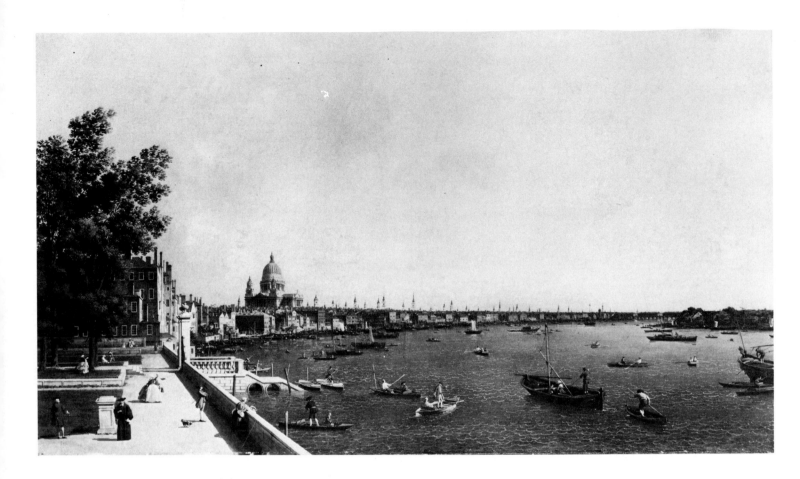

49. *London: the Thames from the Terrace of Somerset House, the City in the Distance.* Canvas, 105.5 × 186.5 cm. (41½ × 73½ in.). Windsor, H.M. The Queen. Both this and the painting shown in Plate 50 were once owned by Consul Smith. Canaletto probably painted them in Venice basing them on the drawings of the same subjects which are now also at Windsor and which were also once owned by Smith.

50. *London: the Thames from the Terrace of Somerset House, Westminster Bridge in the Distance.* Canvas, 106.7 × 185.4 cm. (42 × 73 in.). Windsor, H.M. The Queen.

51. *Westminster Bridge with a distant View of Lambeth Palace.* Pen, ink, wash and pencil, 22.9 × 48.3 cm. (9 × 19 in.). Windsor, H.M. The Queen.

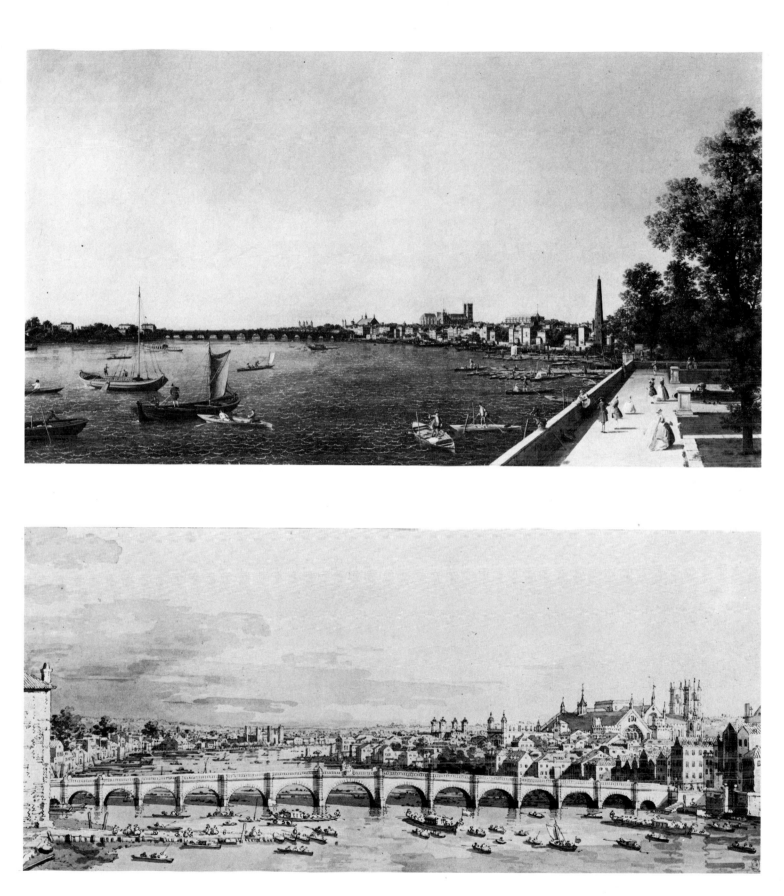

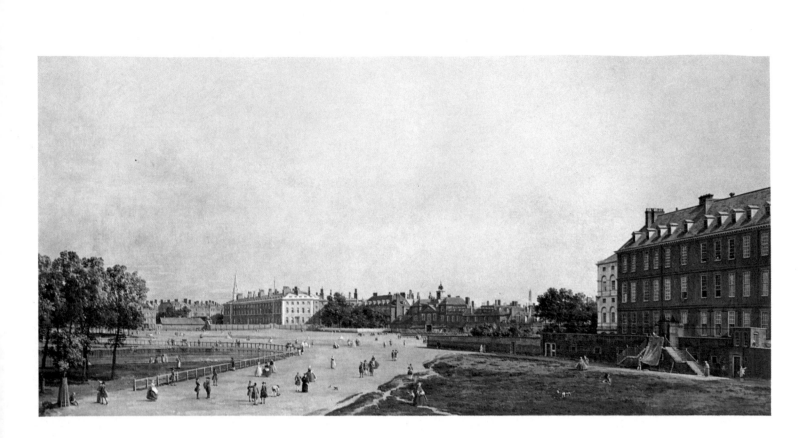

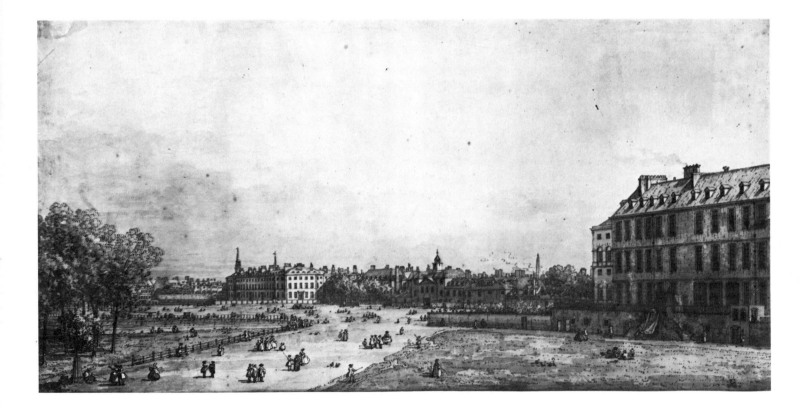

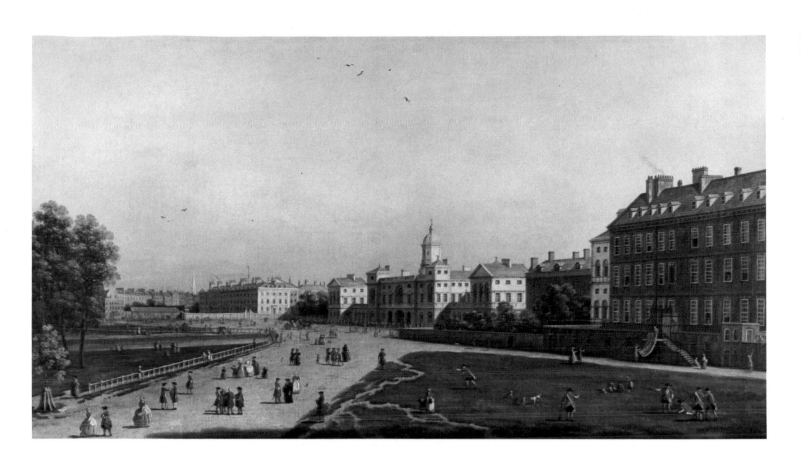

52. *London: the Old Horse Guards from St James's Park.*
Canvas, 122 × 249 cm. (48 × 98 in.). Earl of Malmesbury.

The old Horse Guards was demolished in 1749-50, but this picture may have been painted some time later as it is based on a drawing by Canaletto now in the British Museum (Plate 53). In July 1749 Canaletto advertised in a London newspaper: 'Signor Canaletto hereby invites any gentleman that will be pleased to come to his house to see a picture done by him being a View of St. James's Park, which he hopes may in some manner deserve their approbation any morning or afternoon at his lodgings Mr. Wiggan Cabinet maker in Silver Street Golden Square.'

53. *London: the Old Horse Guards from St James's Park.*
Pen and ink, 33.3 × 68.9 cm. (13 $\frac{3}{16}$ × 27 $\frac{1}{8}$ in.). London, British Museum.

Footmen on the right are shown beating a carpet. This detail is also shown in pictures which Canaletto made of both the Old and the New Horse Guards (see Plates 52, 54), indicating that the drawing was most probably used for both the earlier and later paintings.

54. *London: the New Horse Guards from St James's Park.*
Canvas, 59 × 110.5 cm. (23 $\frac{1}{4}$ × 43 $\frac{1}{2}$ in.) Captain P. J. B. Drury-Lowe.

The picture was probably painted shortly after the completion of the building on the New Horse Guards which was in 1753. An engraving of the view which may have been based on the painting was published in London in November 1753.

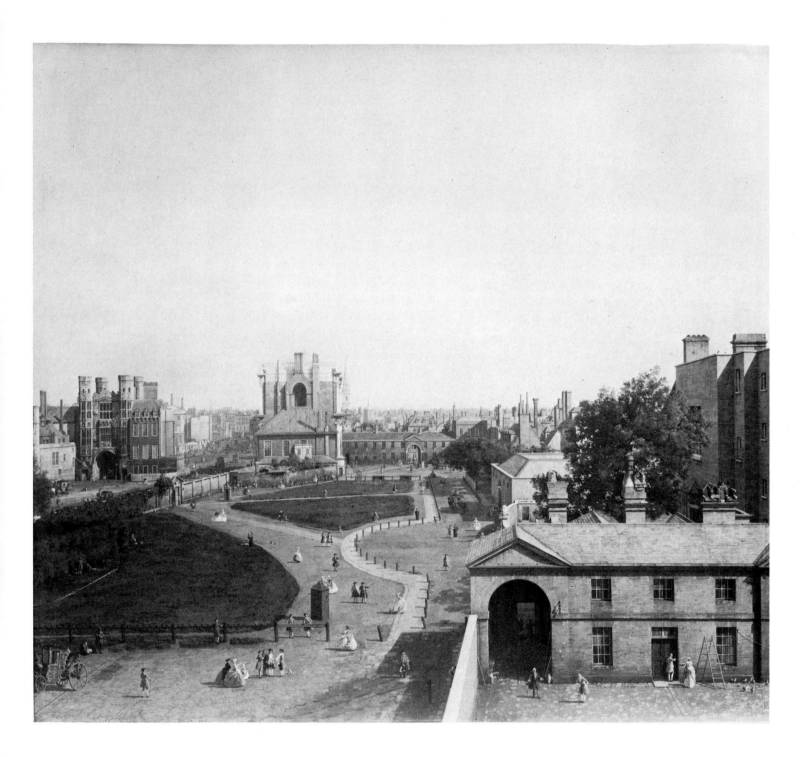

55. *Whitehall and the Privy Garden from Richmond House.*
Canvas, 109.2 × 119.4 cm. (43 × 47 in.). From
Goodwood House by courtesy of the Trustees.

This painting was probably done earlier than the similar
view in Plate 57 and was a pair to the view of the river
from Richmond House shown in Plate 48.

56

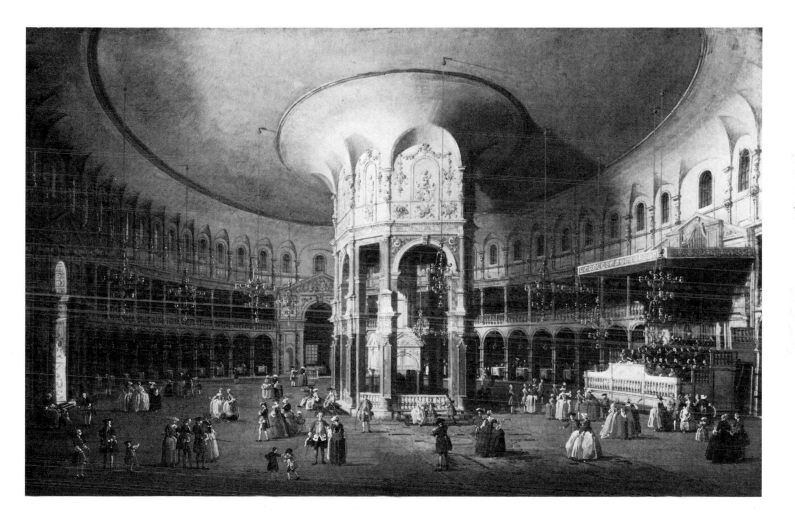

56. *London: Ranelagh, Interior of the Rotunda*. Canvas, 46 × 75.5 cm. (18½ × 29¾ in.). London, National Gallery.

The Rotunda, designed with a central octagonal support by William Jones, was converted and opened to the public as a pleasure resort in 1742. It was closed in 1803 and later demolished.

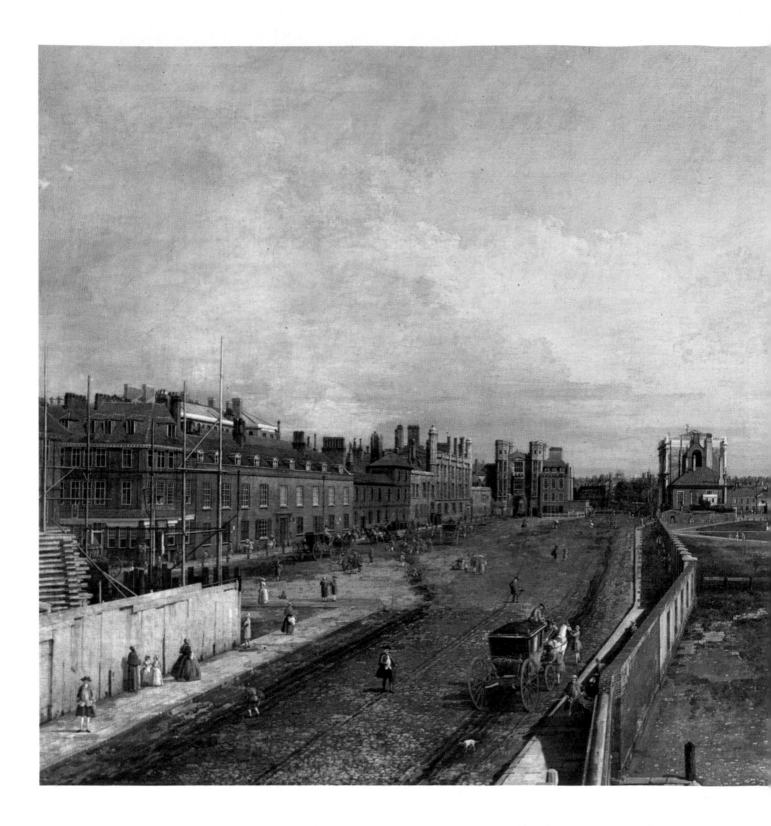

57. *London: Whitehall and the Privy Garden, Looking North*. Canvas, 118.5 × 273.5 cm. (46¾ × 93½ in.). Bowhill, Duke of Buccleuch.

The view is in the direction of Trafalgar Square from what is now Parliament. The tall building in the very centre is the Banqueting House. The picture was origin-

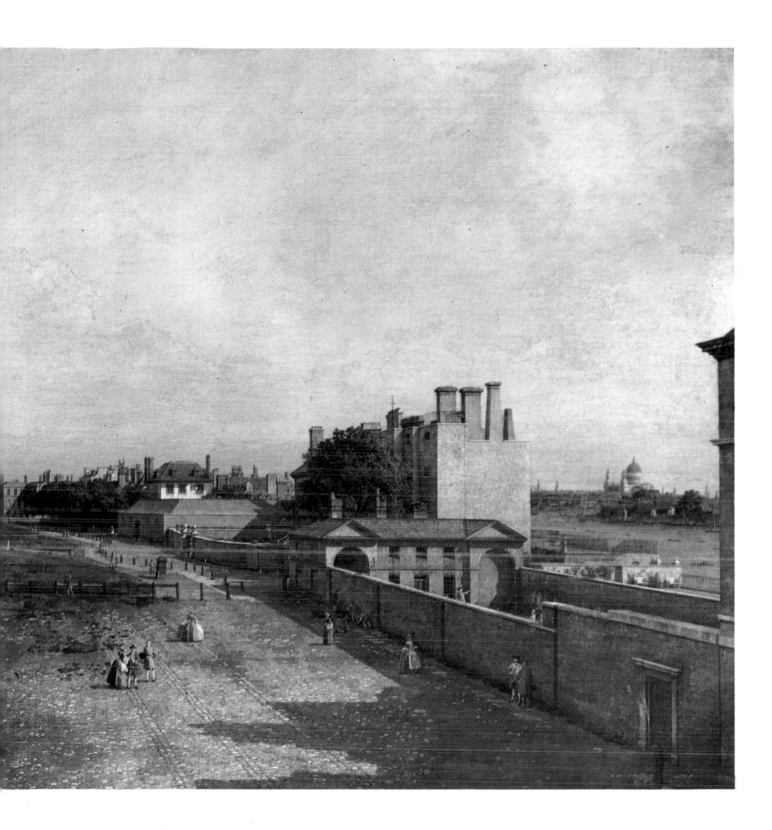

ally bought in 1760 from the artist in Venice; and it is recorded that 'This painting Canaletto, while in England, refused to sell; he wished to keep it as a memento of his visit to our country.' On the evidence of the various states of the buildings it seems likely that the picture was painted in 1751.

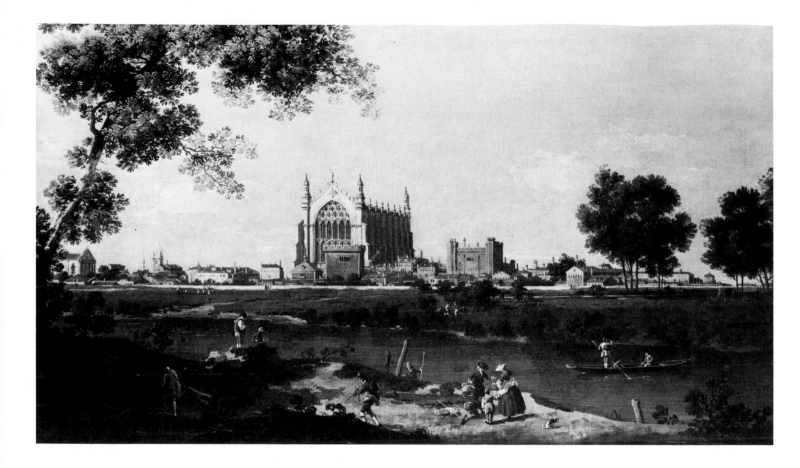

58. *Windsor: Eton College Chapel*. Canvas, 61.5 × 107.5 cm. (24½ × 42⅜ in.). London, National Gallery.

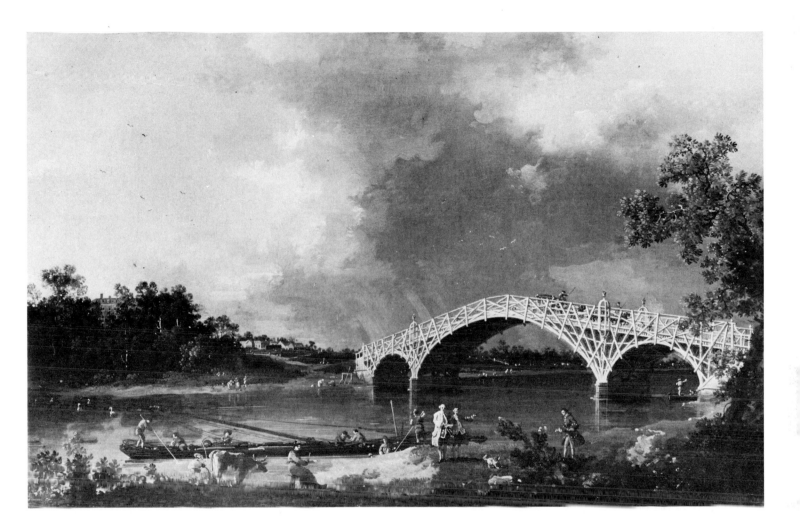

59. *Old Walton Bridge*. Canvas, 46 × 75 cm. (18¼ × 29½ in.). London, Dulwich College Picture Gallery.

Old Walton Bridge was constructed in wood and completed in 1750. It was replaced in 1780. The 1750 construction was paid for by Samuel Dicker, who was M.P. for Plymouth.

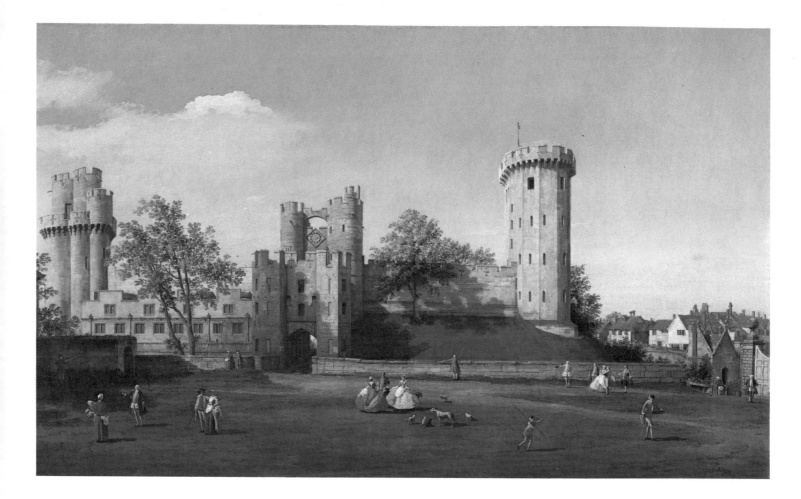

60. *Warwick Castle: the East Front.* Canvas, 73 × 122 cm. (28¾ × 48 in.). Courtesy Marlborough Fine Art.

There are several views of Warwick Castle by Canaletto although it is not known definitely when he went to Warwick. From 1748, however, he made visits from London to several country houses in order to paint them. In that year he painted Badminton, the home of the Duke of Beaufort, and it might well have been on that occasion that he travelled to nearby Warwick.

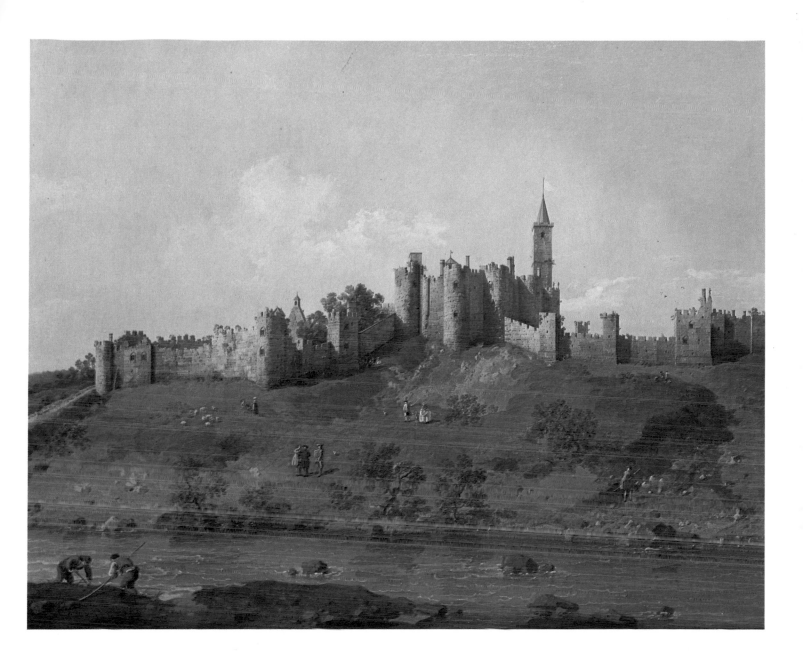

61. *Alnwick Castle, Northumberland*. Canvas, 113.5 × 139.5 cm. (44¾ × 55 in.). Albury Park, Duke of Northumberland.
Alnwick Castle was restored by Robert Adam in 1752-3.

Canaletto's picture shows the castle before the restoration and was probably painted about 1751-2. The picture was commissioned from the painter by the 8th Duke of Northumberland.

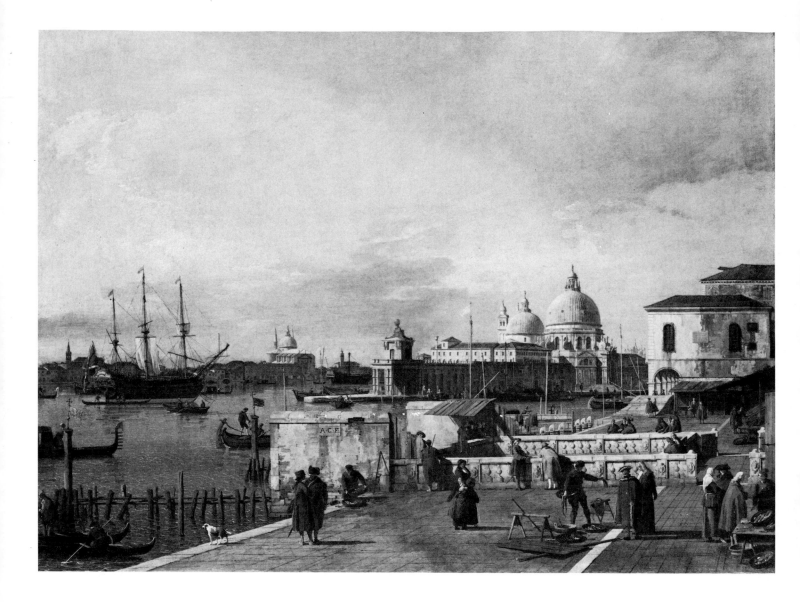

62 and 63. *Entrance to the Grand Canal: from the West End of the Molo*. Canvas, 114.5 × 153 cm. (45 × 60¼ in.). Washington, D.C., National Gallery.
Canaletto's signature appears, almost in the centre of the picture as the large letters A.C.F. on the harbour wall in the foreground. The letters may be interpreted

Antonio Canal Fecit. This picture was formerly at Castle Howard in Yorkshire and may have been seen there as early as 1745 when Lady Oxford wrote in her diary for April 27, 'Set out from York for Castle Howard . . . in the drawing room . . . are several views of Venice by Canaletto lately put up there.'

64

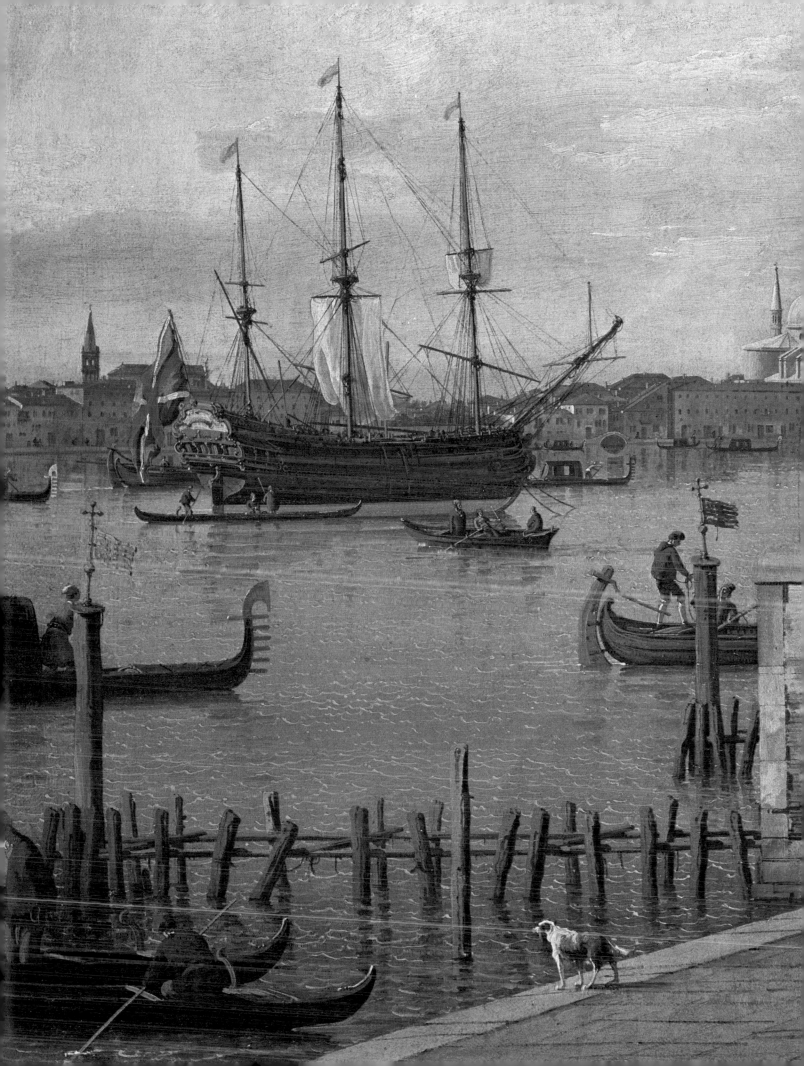

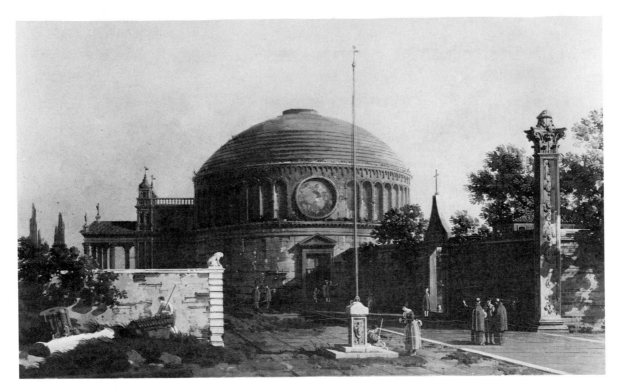

64. *Capriccio: a Domed Circular Church.* Canvas, 44 × 71.5 cm. (17¼ × 28⅛ in.). Massachusetts, Worcester Art Museum.

From about 1740 Canaletto regularly painted this type of picture which is called a *capriccio*. Its essential characteristic is that it is composed of a selection of identifiable motifs, either entire buildings or parts of them, which are arranged into a composition. In this case the church is vaguely reminiscent of the Pantheon in Rome while the lion statue is not unlike that outside the gateway of the arsenal at Venice.

65. *Piazza S. Marco: Looking South.* Canvas, 45 × 76 cm. (18 × 30¼ in.). Dublin, National Gallery of Ireland. This view of the Piazza was probably painted some time late in the 1750s. The view is towards the Procuratie Nuove with the Campanile and, left, the Doge's Palace. The Procuratie Nuove were begun about 1582 by the architect Vincenzo Scamozzi and completed to the designs of Baldassare Longhena about 1640.

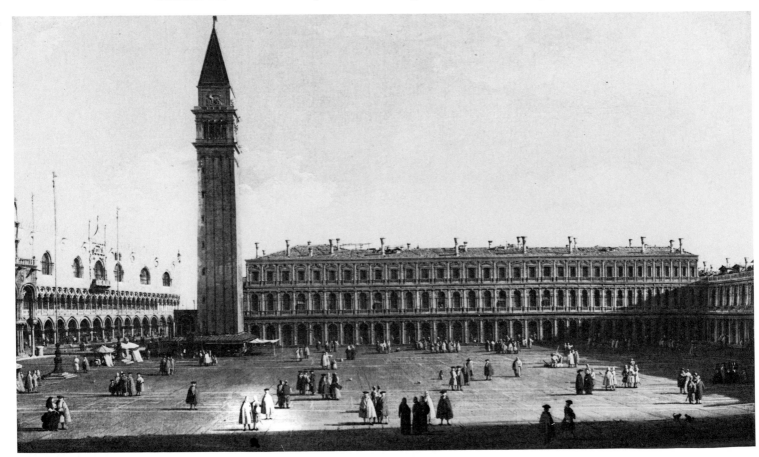

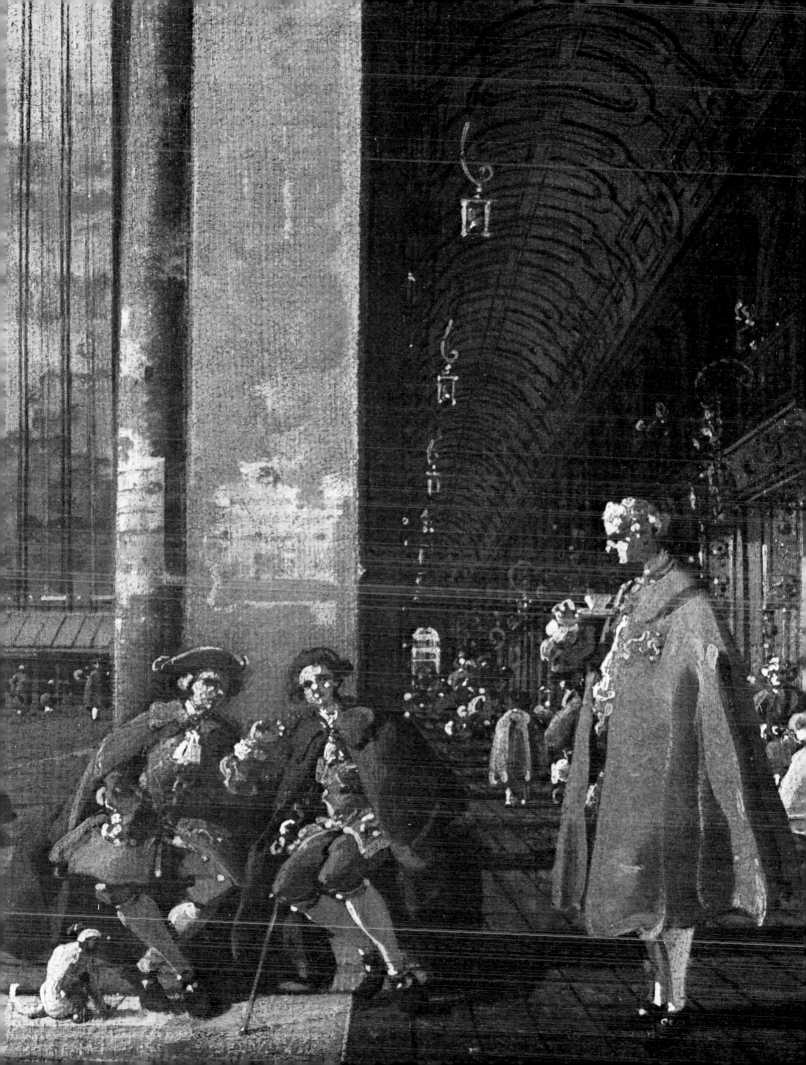

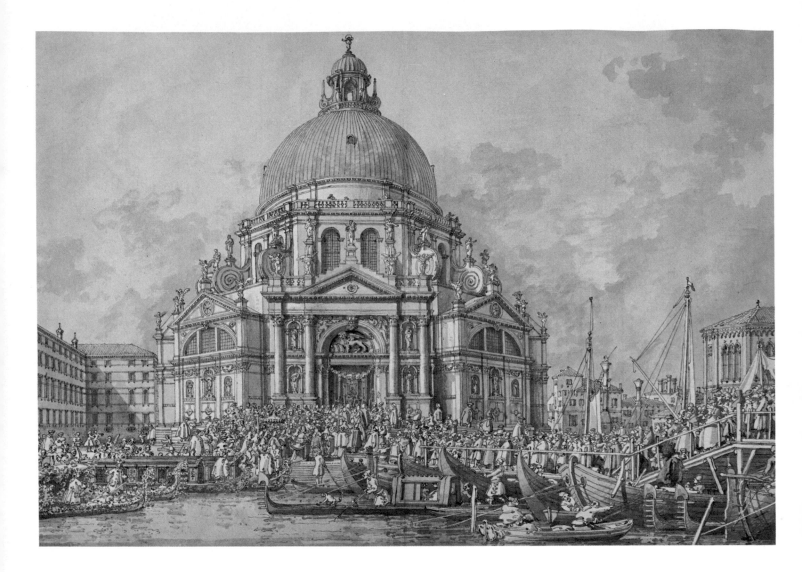

67. *Annual Visit of the Doge to Sta Maria della Salute.*
Drawing, 38.1 × 55.3 cm. (15 × 21¾ in.). Private
Collection.

Sta Maria della Salute was built in gratitude for the
deliverance of the city from the plague in 1630. The
ceremony here represented is the Doge's annual visit of
thanksgiving.

68 (and 66 detail on page 67). *Piazza S. Marco: Looking
East from the South-West Corner.* Canvas, 45 × 35 cm.
(18 × 14 in.). London, National Gallery.

The view is taken from beneath the colonnade of the
Procuratie Nuove. The standing man in the foreground
on the right is holding a cup and saucer and is probably
intended as a patron of the Café Florian, which is just out
of the picture to the right. The picture was probably
painted about 1755.

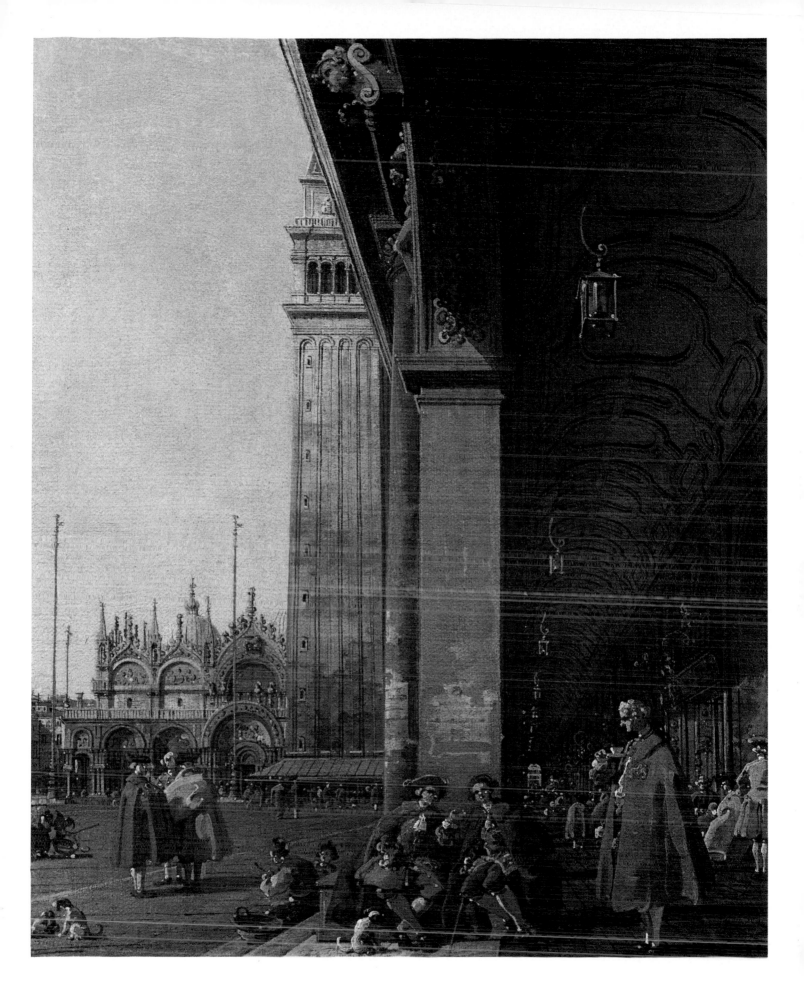

69. *Two Seated Men, and a Third Standing.* Pen and ink and wash, 9.2 × 13.3 cm. ($3\frac{5}{8}$ × $5\frac{1}{4}$ in.). London, National Gallery.

By the time Canaletto painted the picture (Plate 68) for which these three figures are a drawing, the man in the centre had tired of talking and was instead listening to his companion.

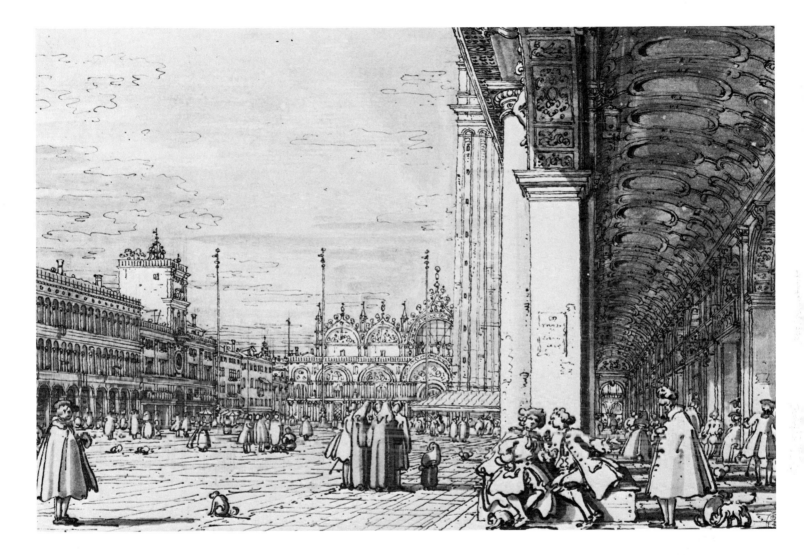

70. *Piazza S. Marco: Looking East from the South-West Corner.* Pen and ink, 19.1 × 27.9 cm. (7½ × 11 in.). Windsor, H.M. The Queen.
This drawing shows a similar, though enlarged composition to that of the painting in the National Gallery (Plate 68).

71 (overleaf). *Grand Canal: Looking South-East from the Campo Sta Sofia to the Rialto Bridge.* Canvas, 119 × 185 cm. (46⅞ × 73 in.). Berlin-Dahlem, Gemäldegalerie. This picture must almost certainly have been painted some time after Canaletto's permanent return to Venice from England in 1756 as it shows the façade, completed in 1751, of the Palazzo Mangilli-Valmarana, which was owned by Consul Smith.

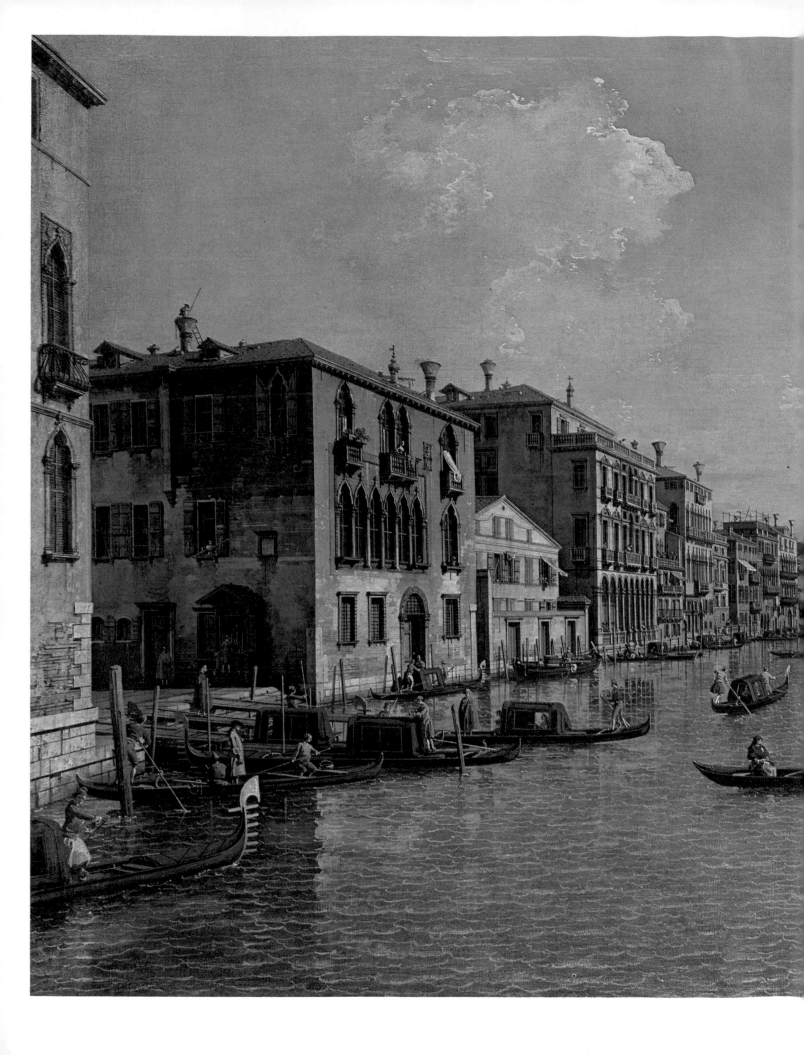

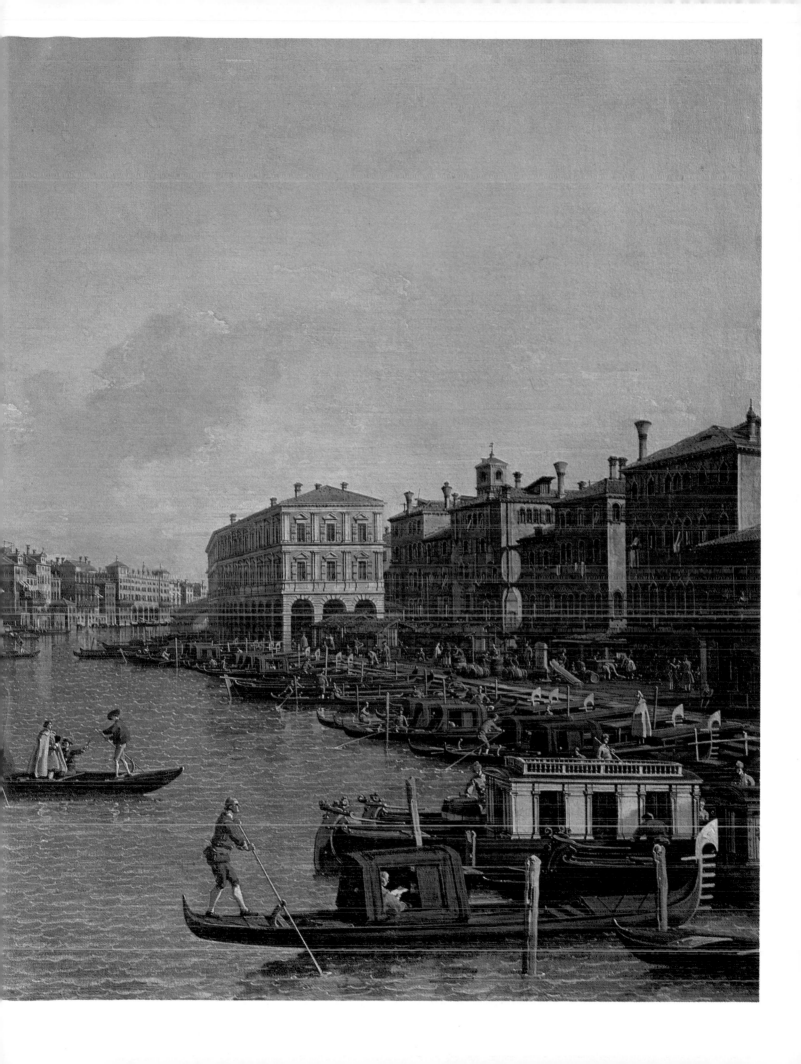

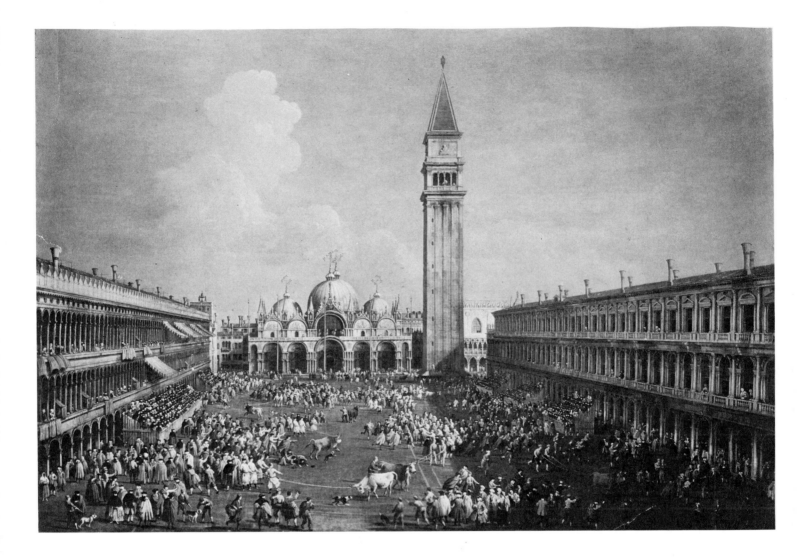

72. *Canaletto and G. B. Cimaroli: A Bull-fight in the Piazza S. Marco*. Canvas, 99 × 145 cm. (39 × 57 in.). Chester, E. Peter Jones.

In 1761, when this painting was in an English collection, it was described as having been painted by Canaletto and Cimaroli. It is not known when the picture was painted and only two bull-fights, in 1767 and 1782, are recorded as having taken place in the Piazza S. Marco. The design of the picture is probably Canaletto's and the finishing Cimaroli's.

73. *Capriccio: with S. Giorgio Maggiore and the Bridge of the Rialto*. Canvas, 165 × 114.5 cm. (65 × 45 in.). Raleigh, North Carolina Museum of Art.

This picture, which shows two of the most famous Venetian landmarks, S. Giorgio Maggiore and the Rialto Bridge placed alongside each other, may have been painted in England. The church is, of course, on the island of S. Giorgio and the Rialto Bridge spans the Grand Canal at the centre of the city.

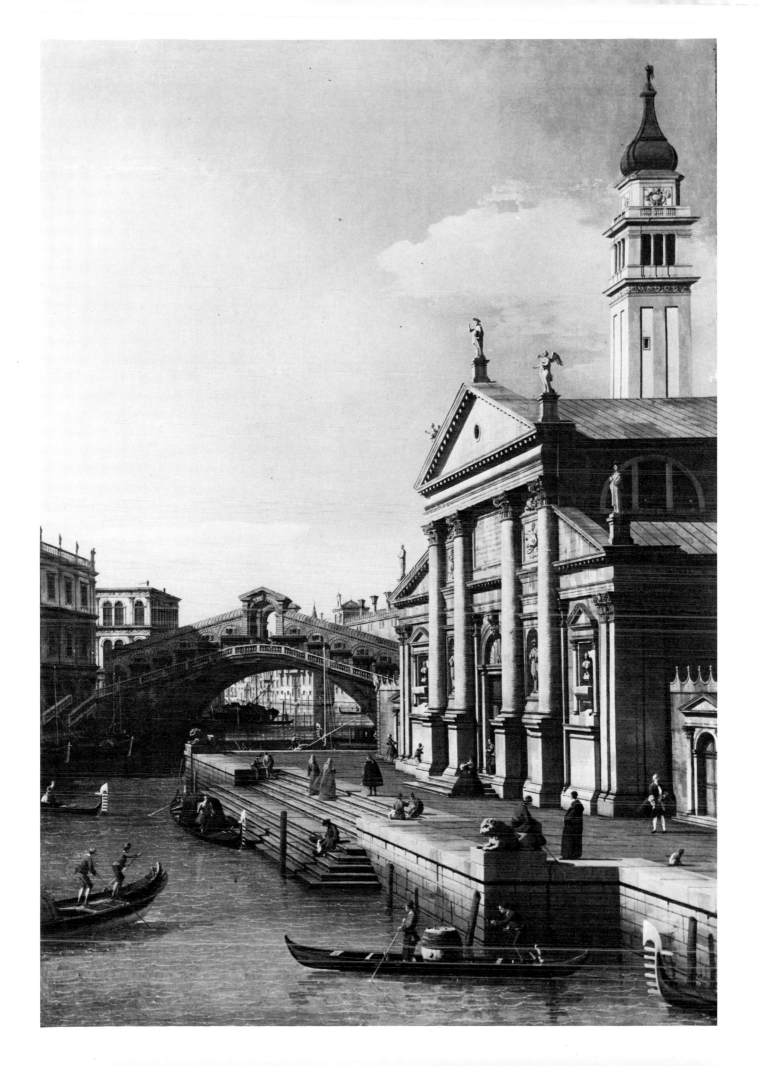

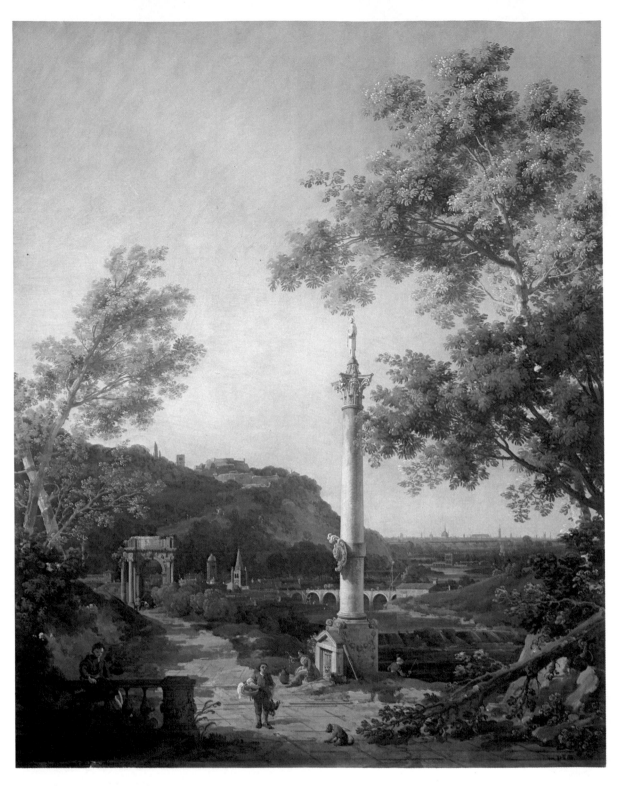

74. *Capriccio: River Landscape with a Column, a Ruined Roman Arch and Reminiscences of England.* Canvas, 132 × 104 cm. (52 × 41 in.). Washington, National Gallery.

This is one of a group of *capricci* in similar style, one of which is dated 1754, and all of which were probably painted in England. In the present picture the countryside seems quite English, but the buildings are more Italianate.

75. *Rome: the Piazza del Campidoglio and the Cordonata.* Detail of Plate 76.

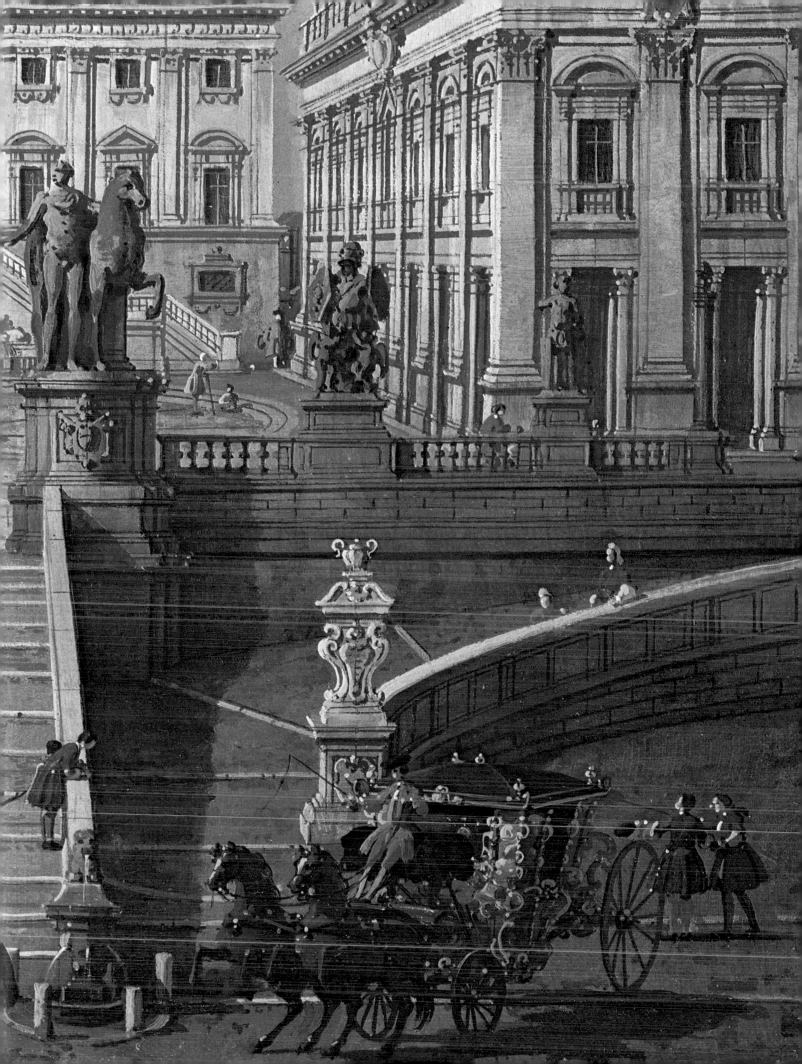

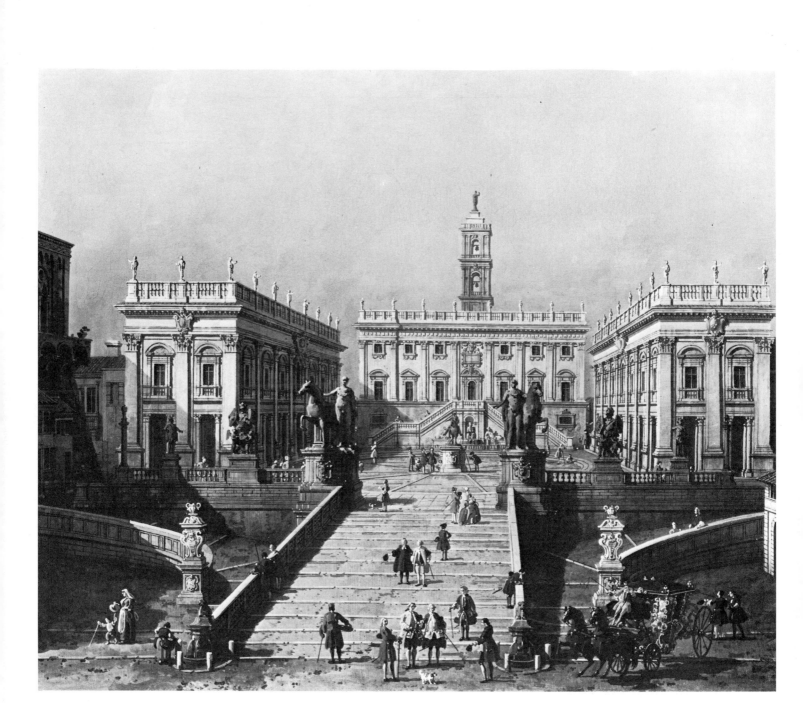

76. *Rome: the Piazza del Campidoglio and the Cordonata.*
Canvas, 52.1 × 61.3 cm. (20½ × 24⅛ in.). United States,
Private Collection.
The Cordonata is the flight of steps leading to the Capitol.

An old label on the back of this picture records that it
was painted in London in 1755 for Thomas Hollis, who
was a wealthy collector-politician. For another Roman
painting by Canaletto see Plate 35.

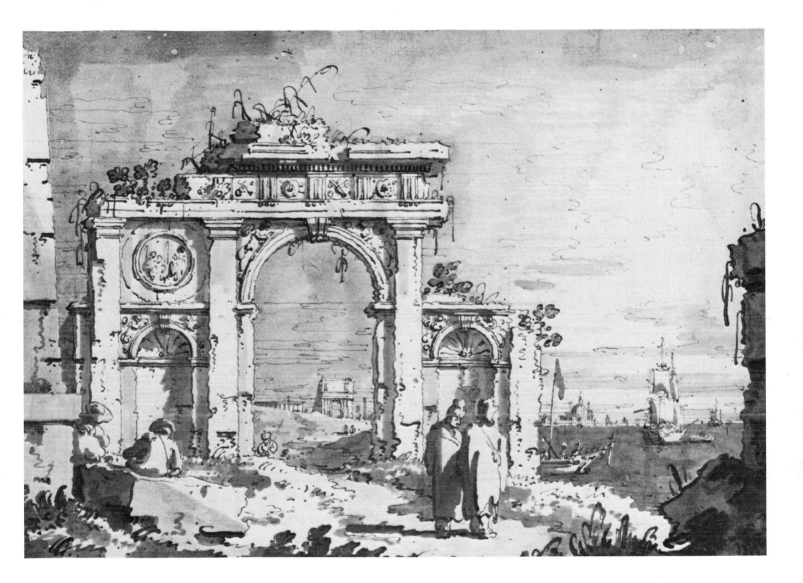

77. *Capriccio: a Classic Triumphal Arch by the Lagoon.*
Pen and ink over pencil, 19.4 × 27 cm. (7⅝ × 10¹¹⁄₁₆ in.).
Windsor, H.M. The Queen.

This drawing is similar in composition to a painting by
Carlevaris. Both were once owned by Consul Smith and
subsequently sold by him to George III.

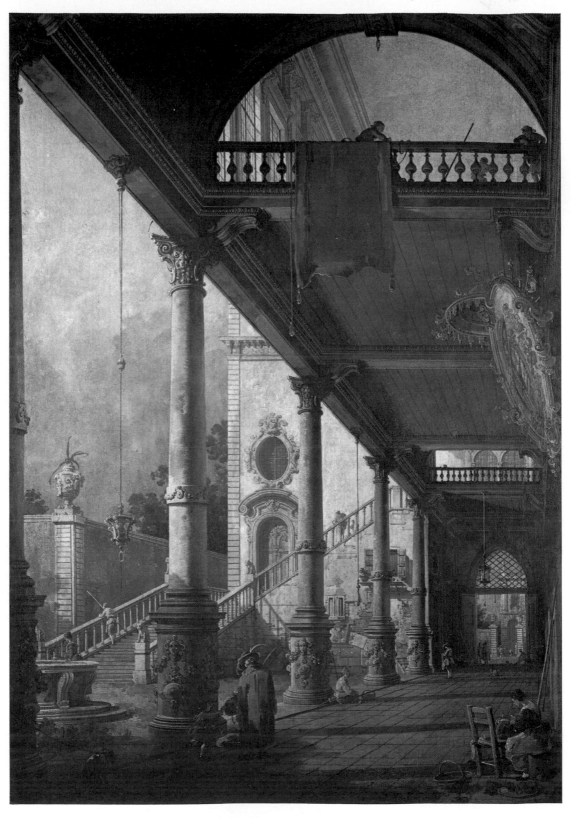

78. *Capriccio: a Colonnade Opening on to the Courtyard of a Palace*. Canvas, 131 × 93 cm. (51½ × 35½ in.). Venice, Gallerie dell'Accademia.
This is the last known painting by the artist and was presented by him to the Accademia di Pittura e Scoltura in Venice after his election in 1763. It is signed and dated 1765. Although Canaletto lived for a further twelve years after his final return to Venice from England in 1756, there are relatively few paintings known by him dating from this period.